Bevalet's Hummingbirds And Flowers:
A Vintage Grayscale Adult Coloring Book

By Ligia Ortega
ColoringPress.com

This book is dedicated to Deirdre. Thank you for your encouragement, laughs, and for the kindness you give.

Artist's Message

It means so much that you have chosen to purchase this book. I hope it brings you or a loved one hours of coloring pleasure.

All images in this book were lovingly sourced, curated, and restored by me. I then worked to carefully convert every image to high-quality colorable grayscale, digitize every page and assemble them electronically to prepare for printing. This coloring book has been a true labor of love, representing months of work (plus sleep deprivation and neglect of friendships and housework!). Although the source images are public domain, the work I have done to restore and convert these images into grayscale coloring pages is protected by Copyright Law. I took the time and additional expense to officially register this book with the Copyright Office. Please respect Copyright Law.

You may:

Copy the uncolored pages on other paper preferences for yourself.
Post colored images on social media.
Give the colored pages as gifts.
Give a physical book you purchased as a gift.

You may not:

Share physical or electronic copies of uncolored pages with anyone else, whether free or for sale.
Post uncolored pages anywhere online, claim them as your own, or distribute uncolored pages via e-mail or electronic downloads.
Incorporate uncolored or colored images on items besides colored pages.
Sell uncolored or colored images, cards, or crafts made with the coloring pages, use them on products, or for any commercial usage.

Copyright © 2017 Ligia Ortega. All rights reserved. I am grateful for your support of artist/author's rights.

In accordance with the U.S. Copyright Act of 1976, the scanning, uploading, and electronic sharing of any part of this book without the permission of the artist/author constitutes unlawful **piracy** and **theft** of the artist/author's intellectual property except for the provisions above. Coloring any image does not transfer copyright or any rights to you, nor does it create a new copyright in your name. If you would like to use material from the book, prior written permission must be obtained by contacting the artist/author at:

ColoringGifts@yahoo.com ColoringPress.com www.facebook.com/ColoringPress

ISBN: 978-1979972215

ISBN: 1979972214

THIS BOOK BELONGS TO:

Illustrations

Scientific names, listed in order of appearance

- Acestura Mulsanti
- Augastes Lumachellus
- Aurinia Verreauxi
- Bellona Cristata
- Cephallepis Delandii
- Chactocercus Bombillus
- Chalybura Melanorrhoa
- Circe Magica
- Clytolaema Matthewsi
- Cyanomya Microrhyncha
- Cynanthus Caelestis
- Eriocnemis Dyselia
- Eucephala Subcaerulea
- Eucnemis Chrysorama
- Eudosia Traviesi
- Eugenia Imperatris
- Eulampis Holosericeus
- Eupherusa Poliocerca
- Eustephanus Ferdinandensis
- Eustephanus Galeritus
- Heliactin Cornuta
- Heliangelus Spencei
- Hellopaedica Xanthusi
- Lampropygia Boliviana
- Lesbia Nuna
- Leucolia Viridi-frons
- Lucaria Costea
- Metallura Smaragdinicollis
- Oreopyra Cinereicauda
- Oreopyra Hemileuca
- Oreopyra Leucaspis
- Panterpe Insignis
- Petasophora Cyanotis
- Ramphomicron Microrhynchus
- Ramphomicron Olivaceus
- Saturia Isaacsoni
- Telamon Regulus and Telamon Strictilophus

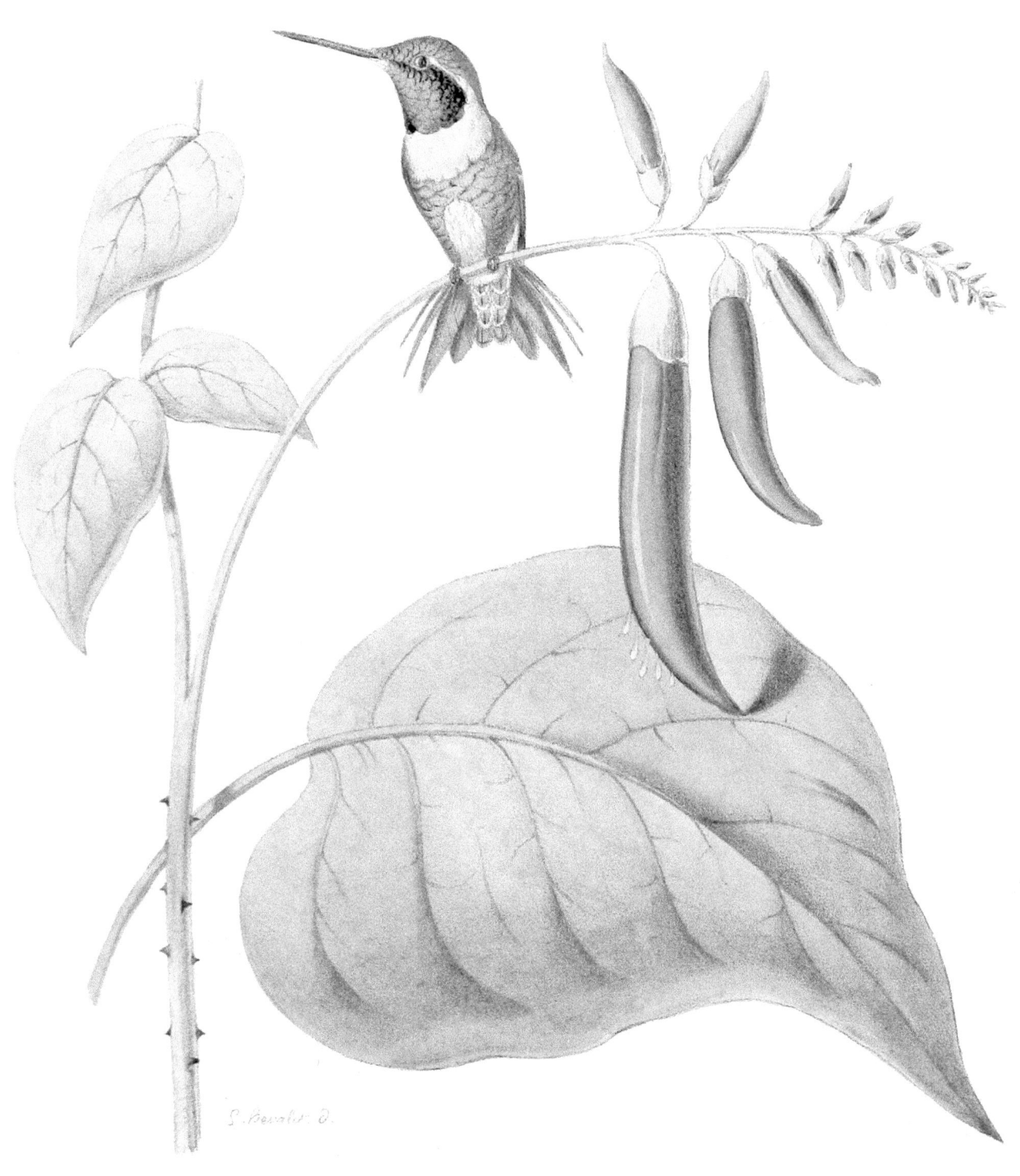

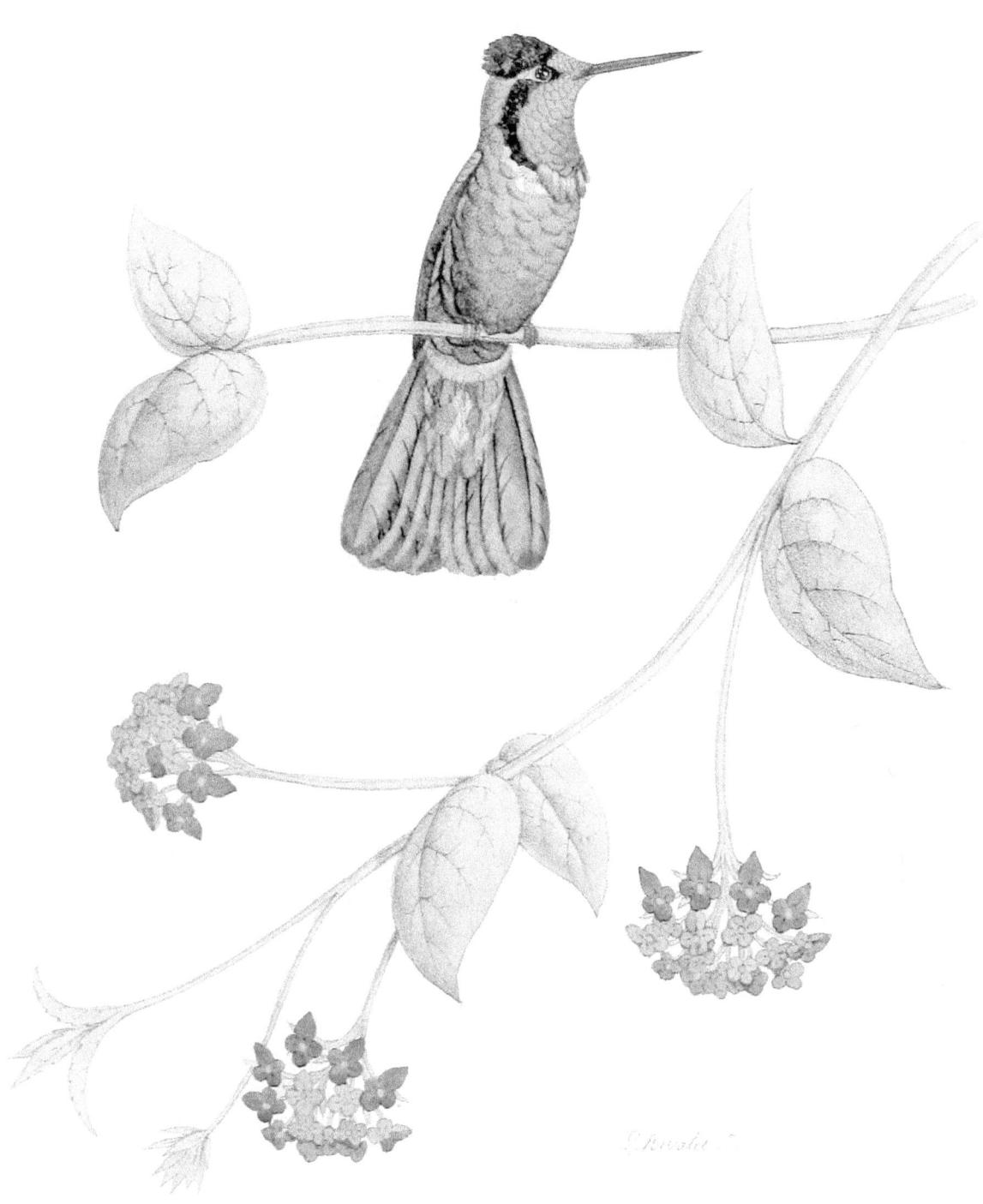

Bevalet's Hummingbirds and Flowers

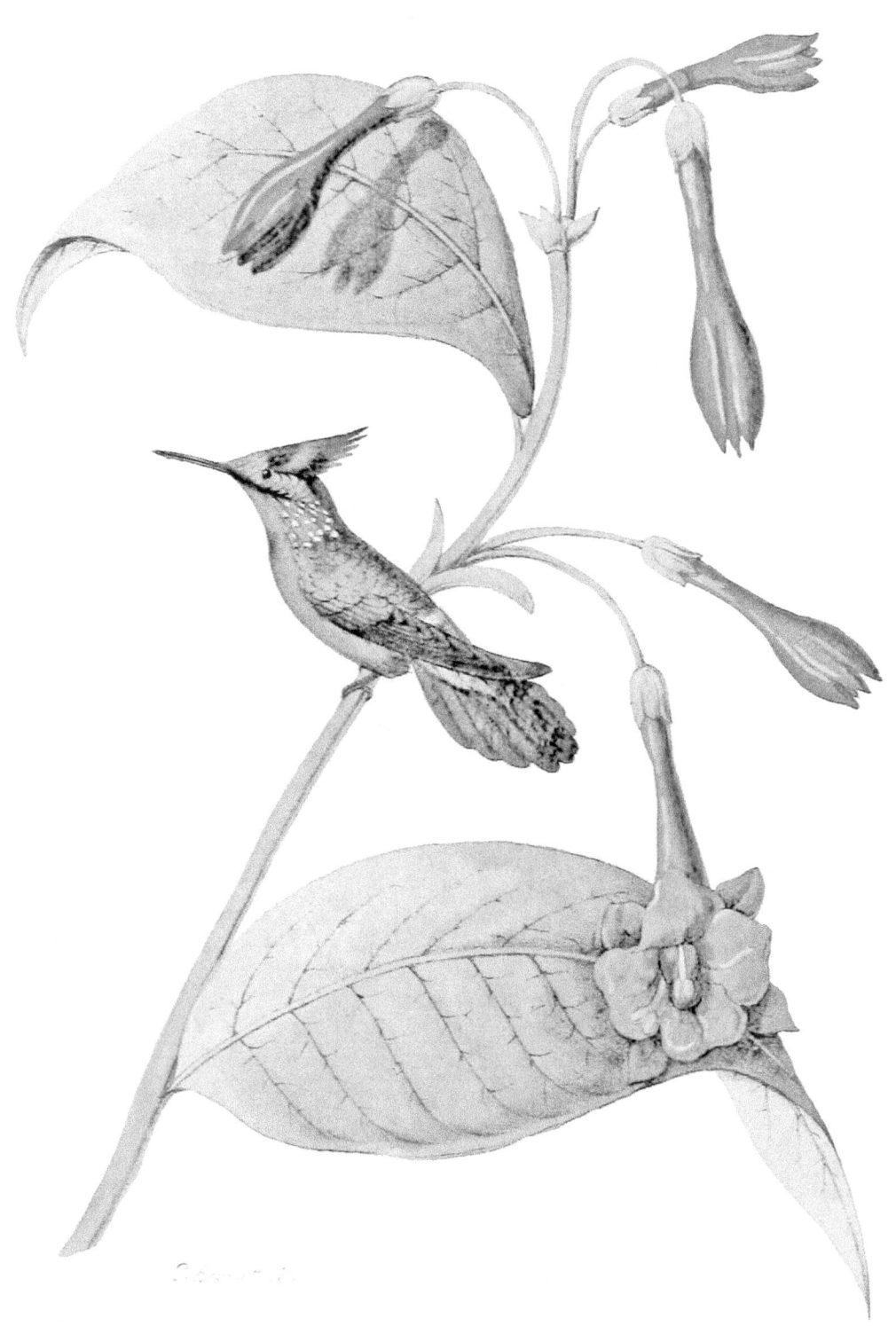

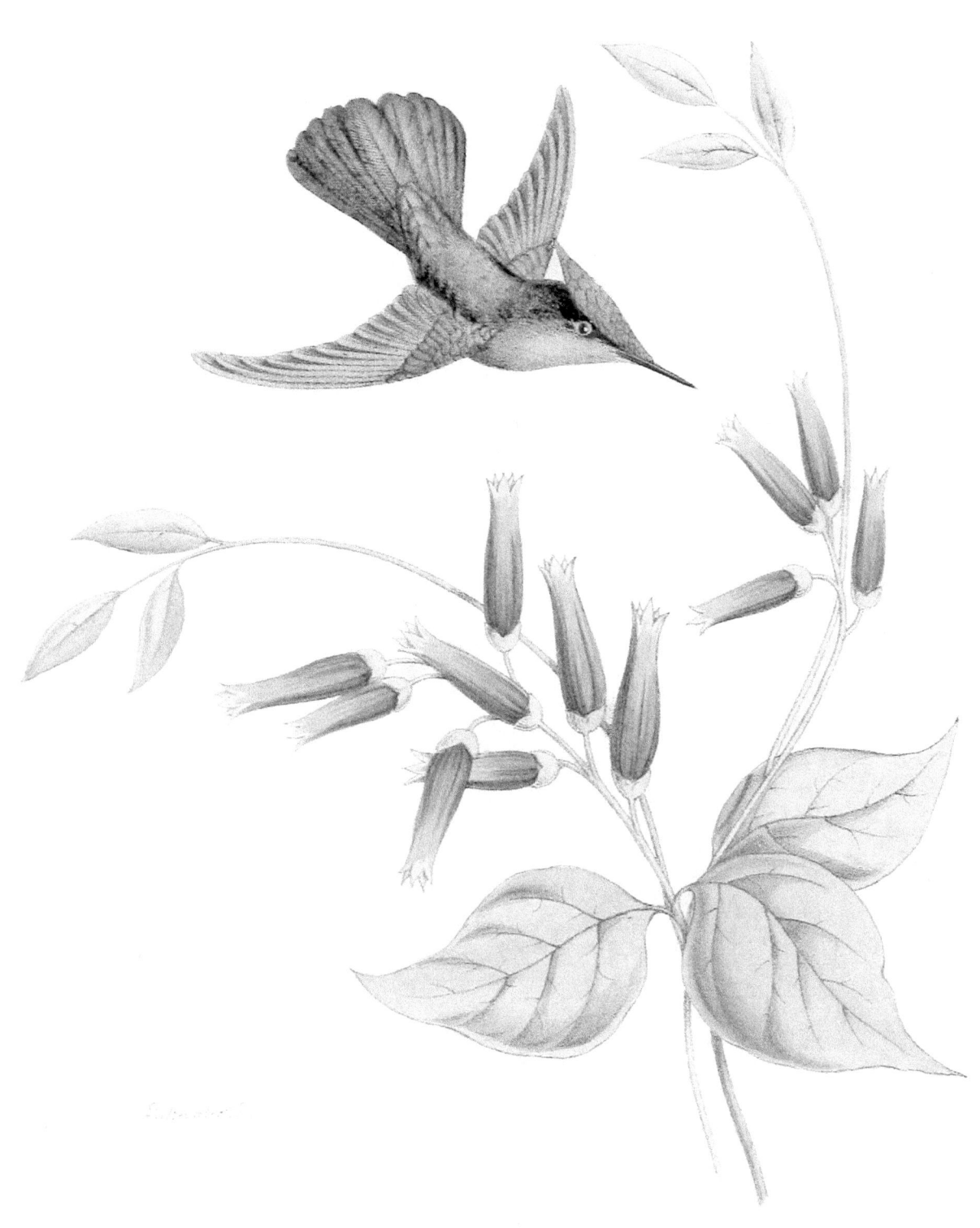

Bevalet's Hummingbirds and Flowers © Ligia Ortega - ColoringPress.com

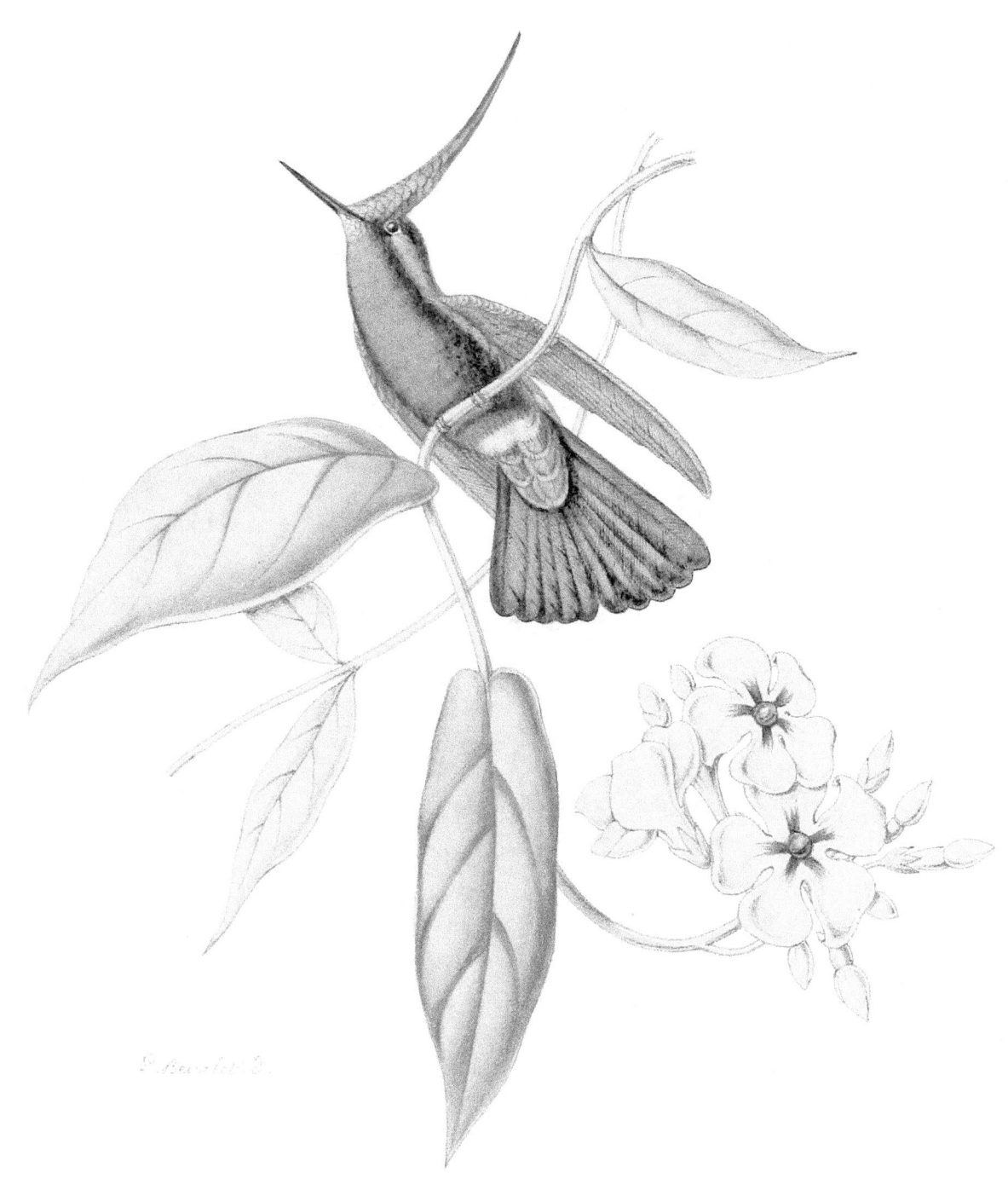

Bevalet's Hummingbirds and Flowers

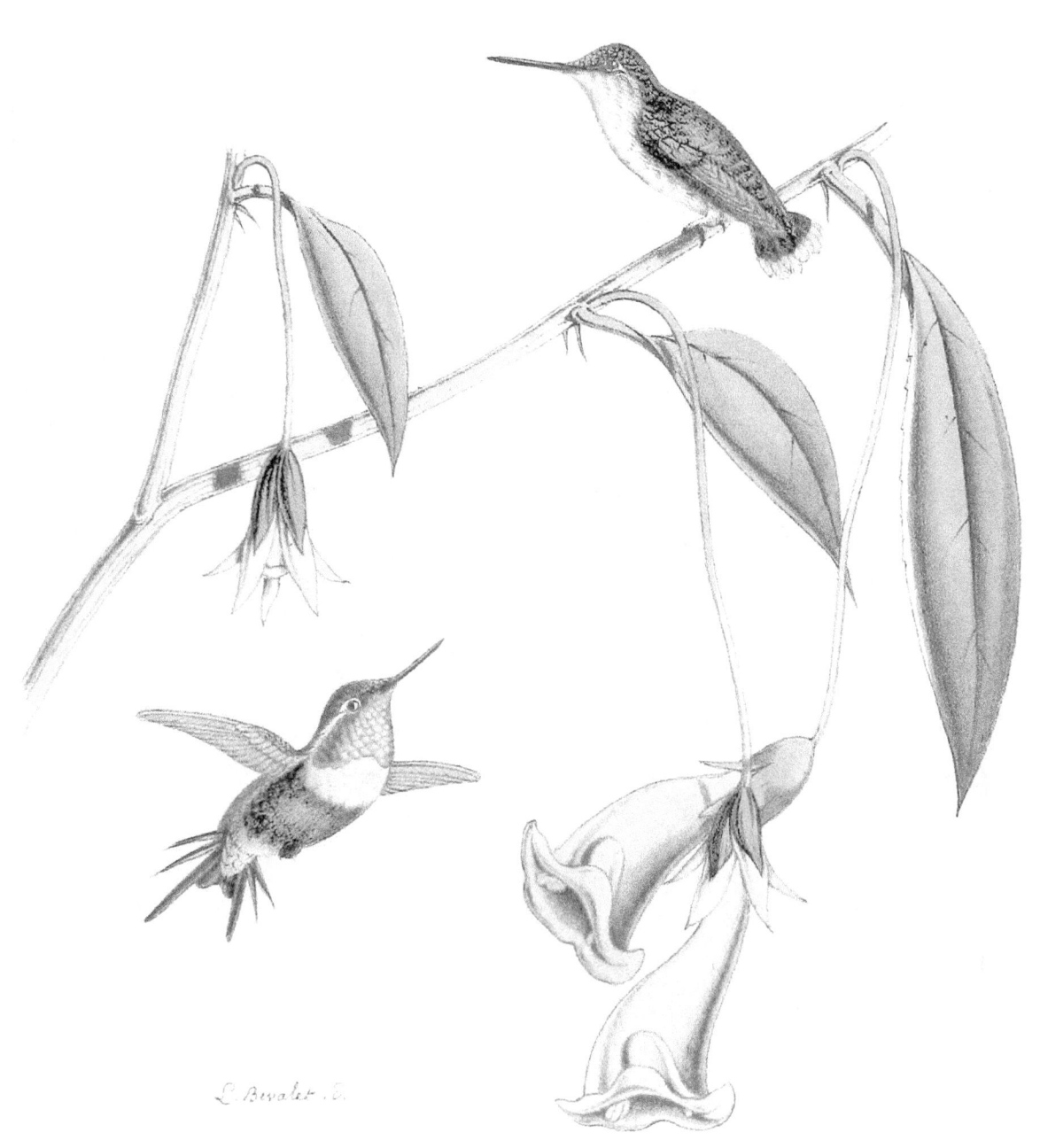

Bevalet's Hummingbirds and Flowers

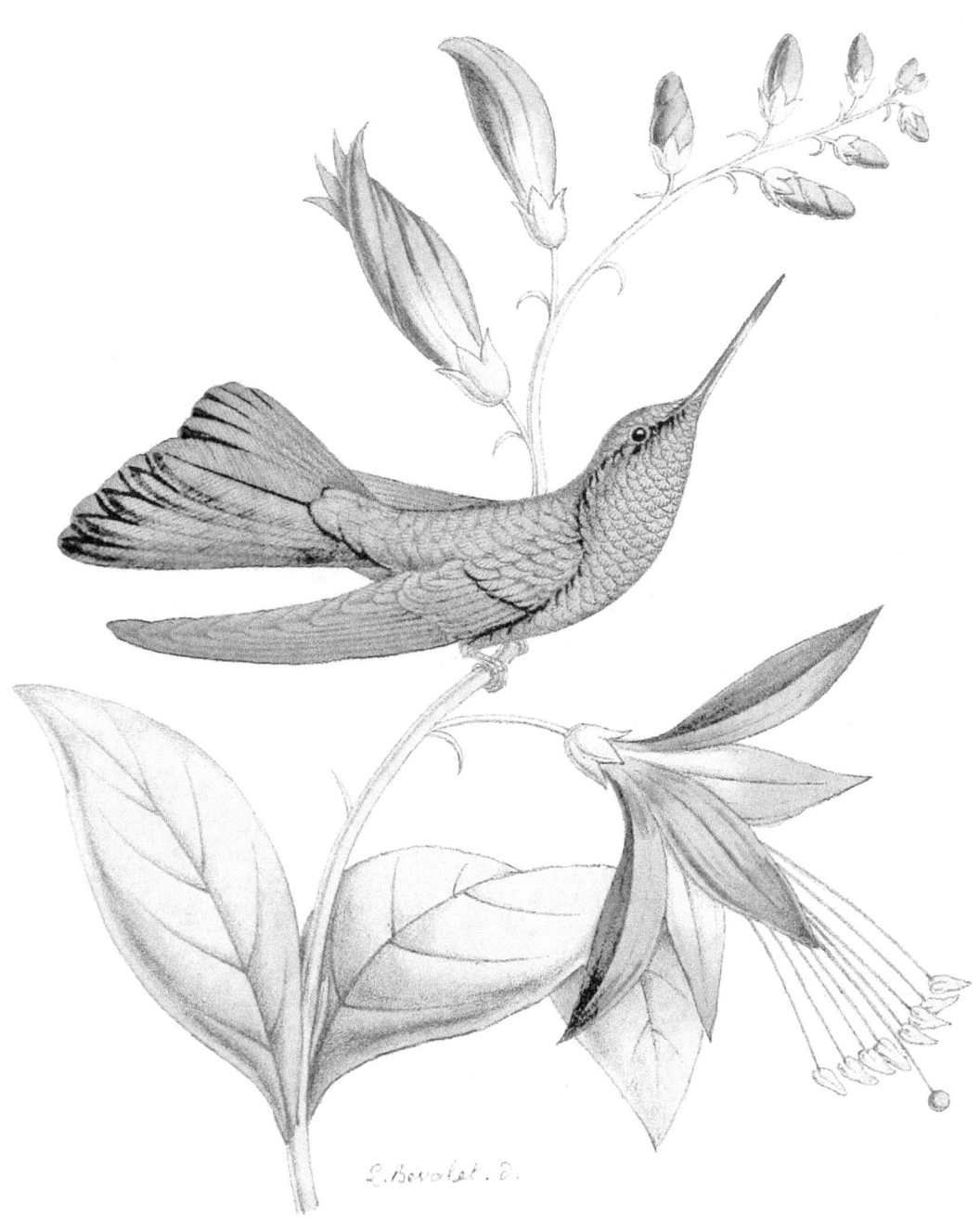

Bevalet's Hummingbirds and Flowers

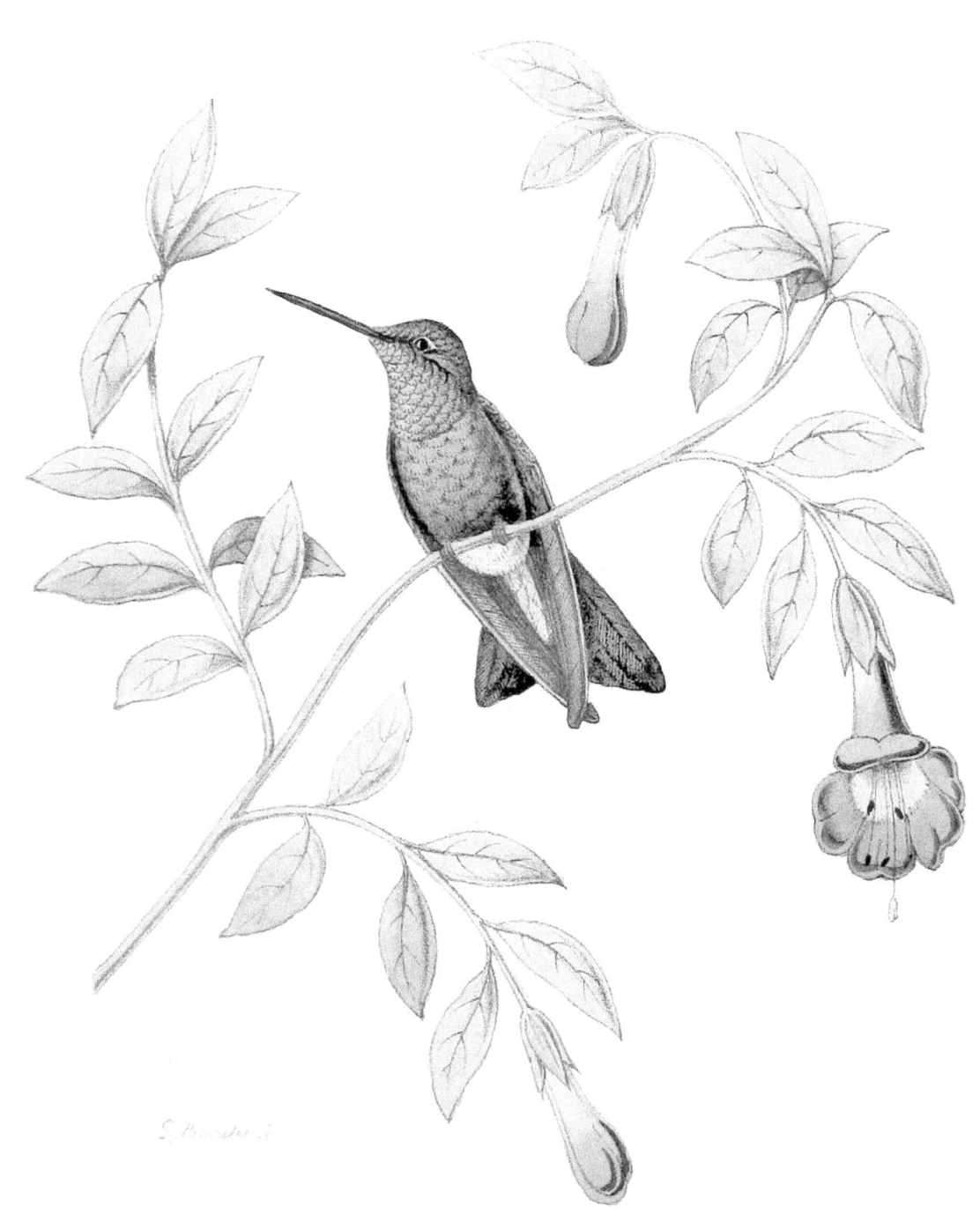

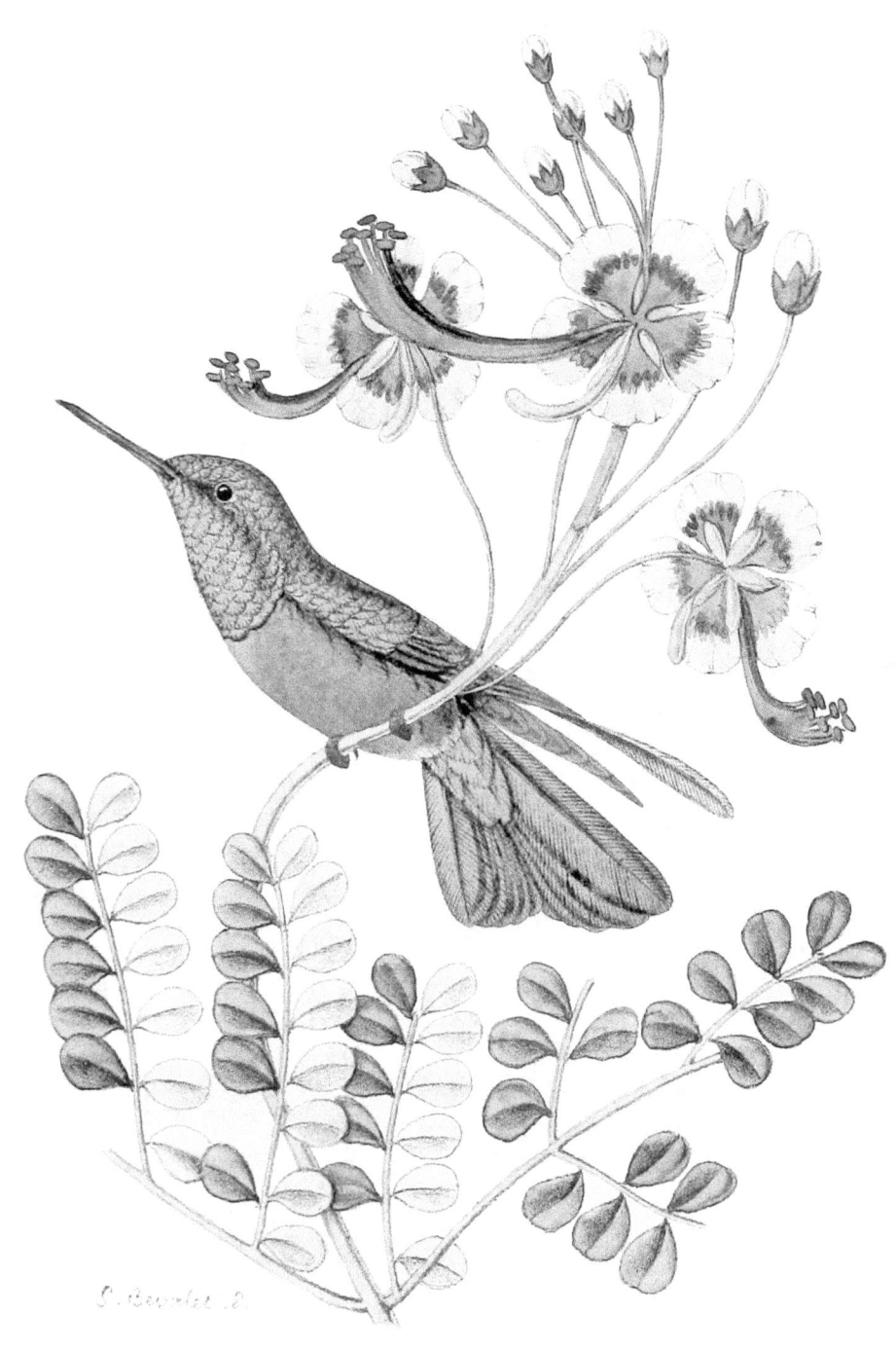

Bevalet's Hummingbirds and Flowers

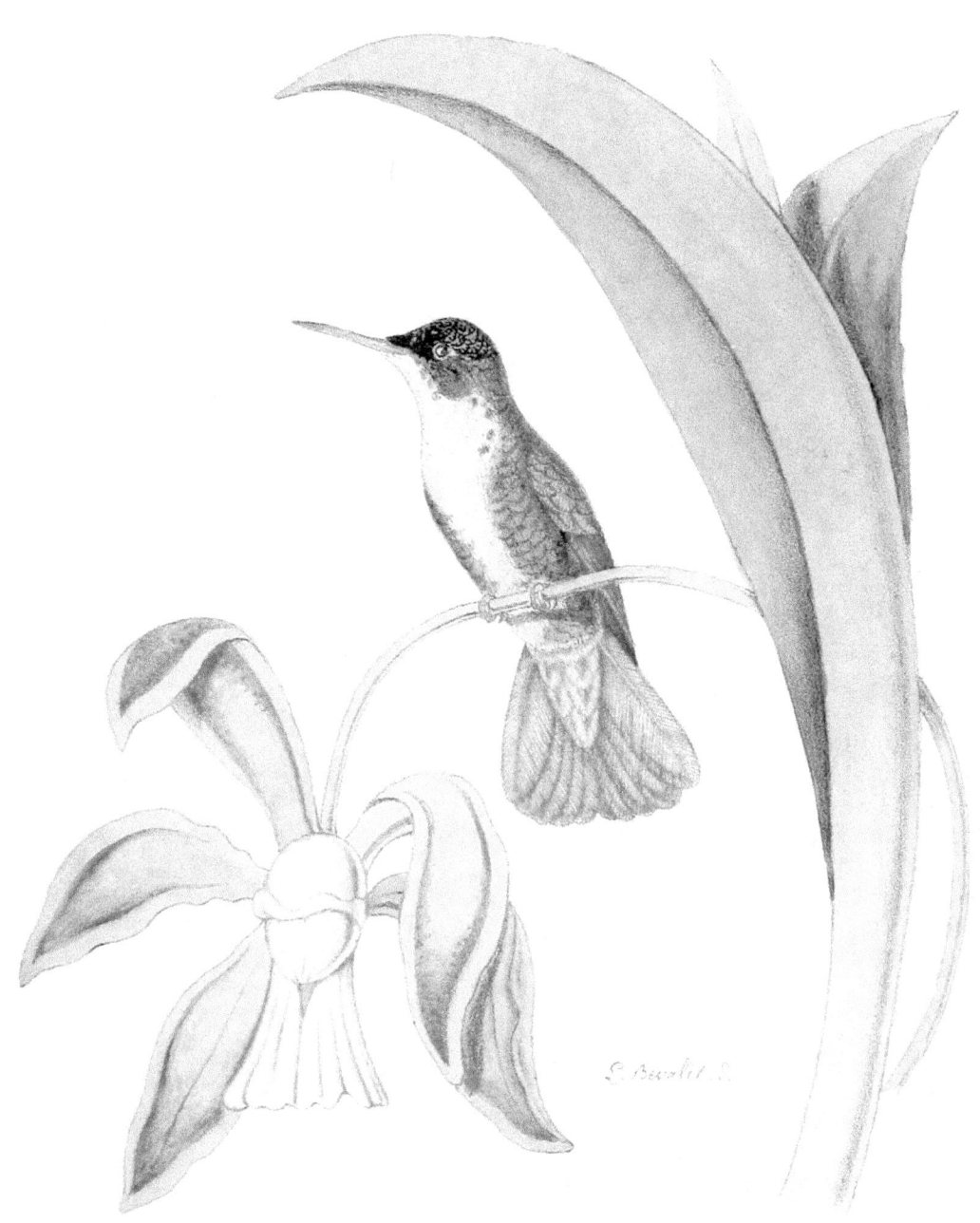

Bevalet's Hummingbirds and Flowers

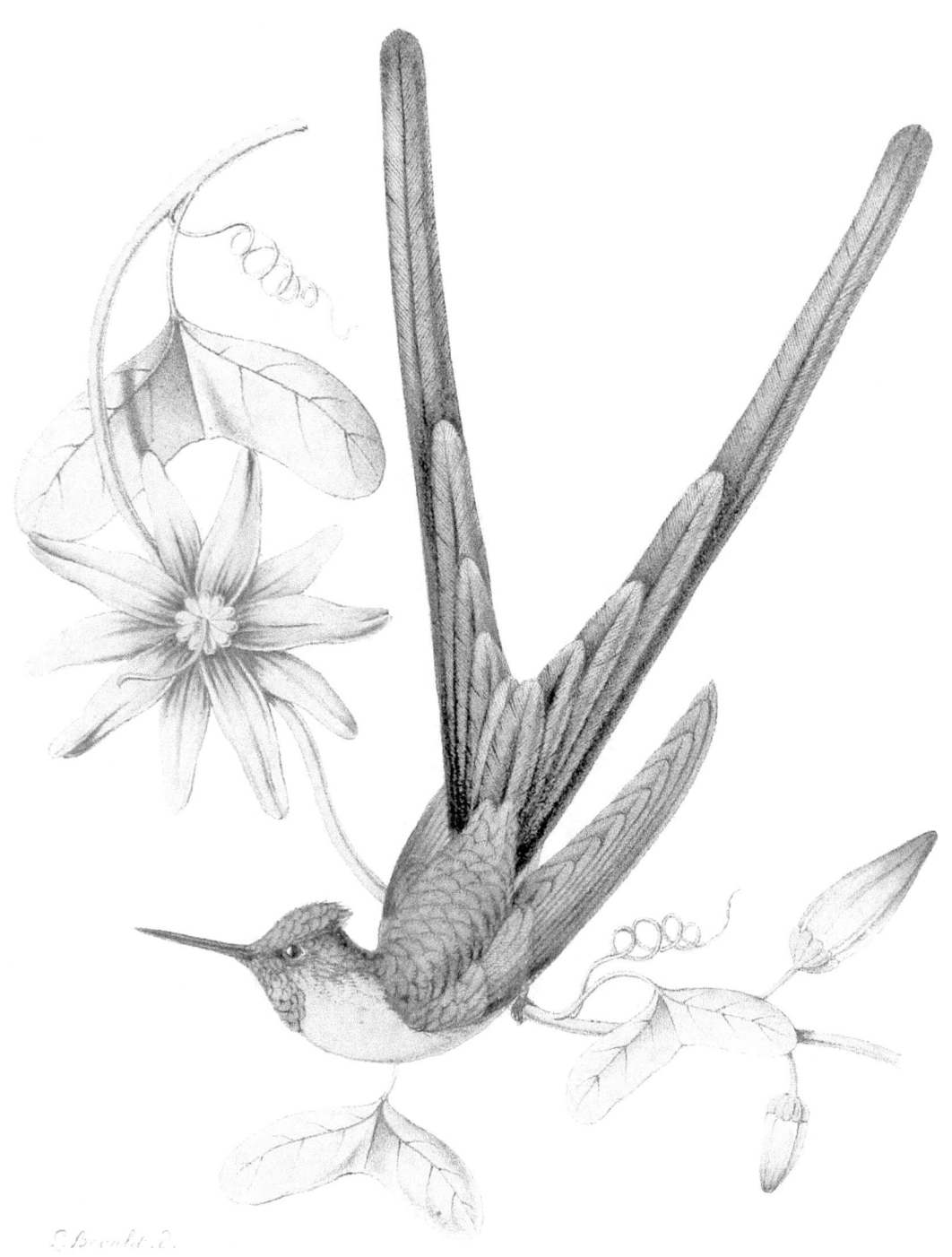

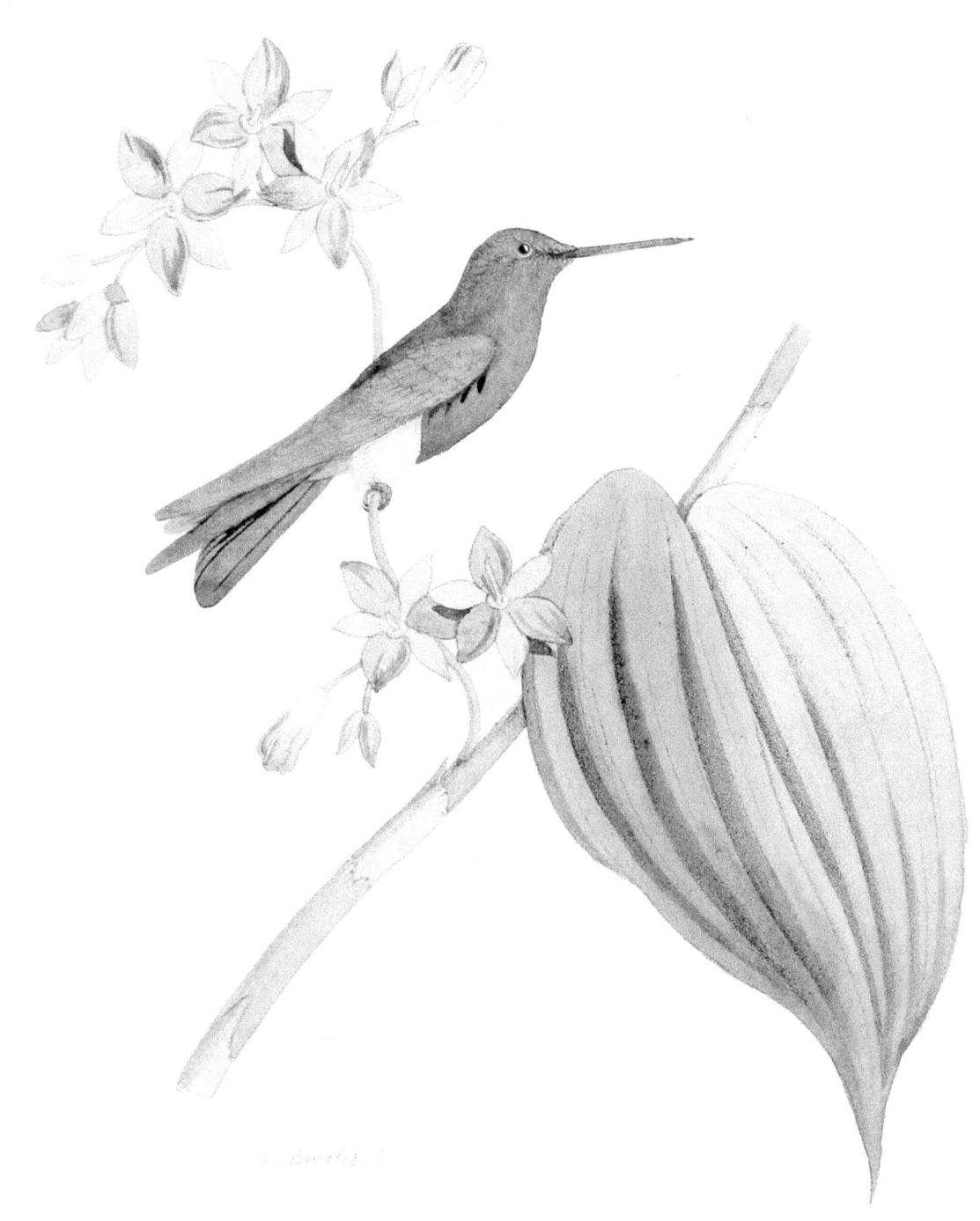

Bevalet's Hummingbirds and Flowers

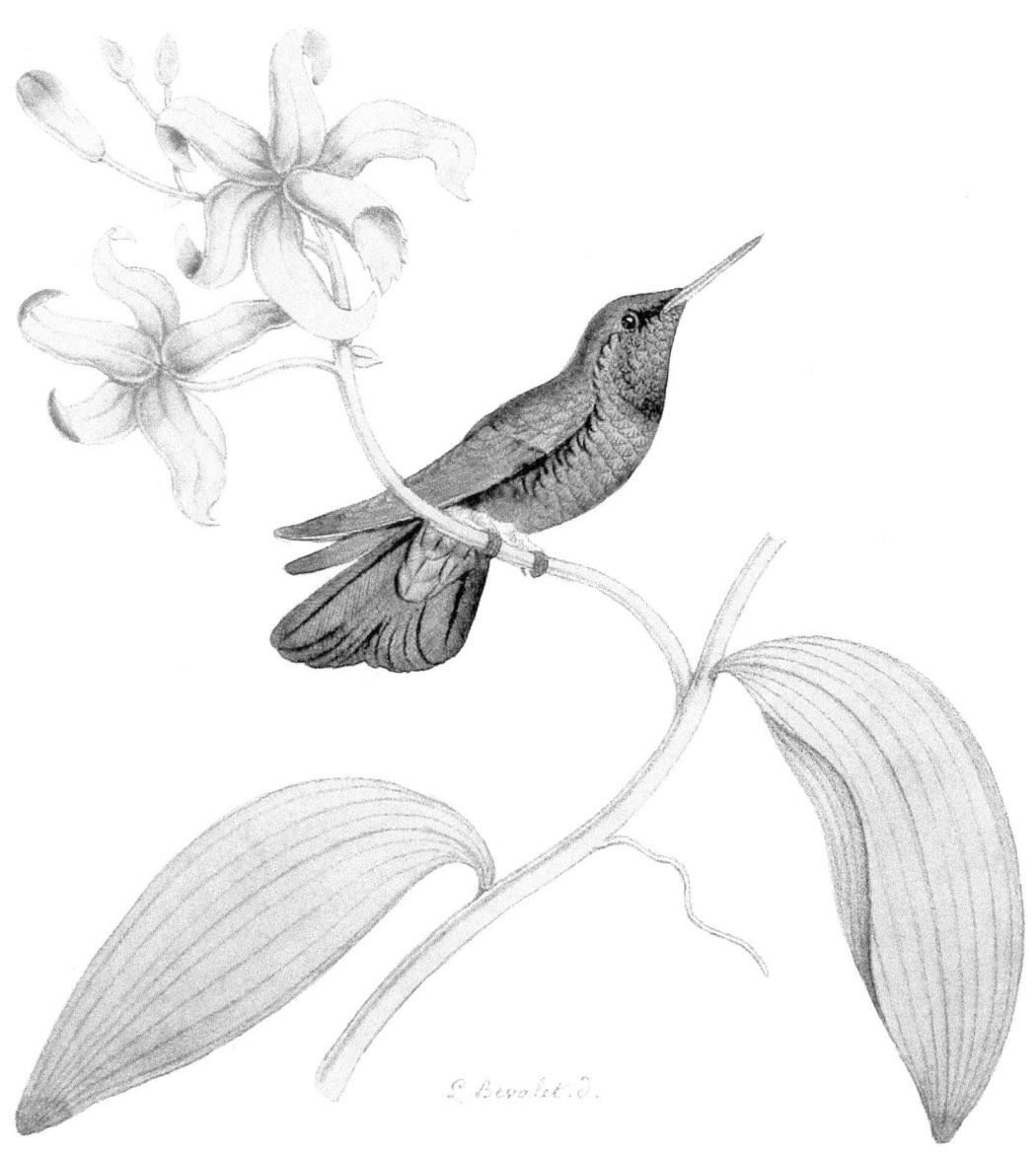

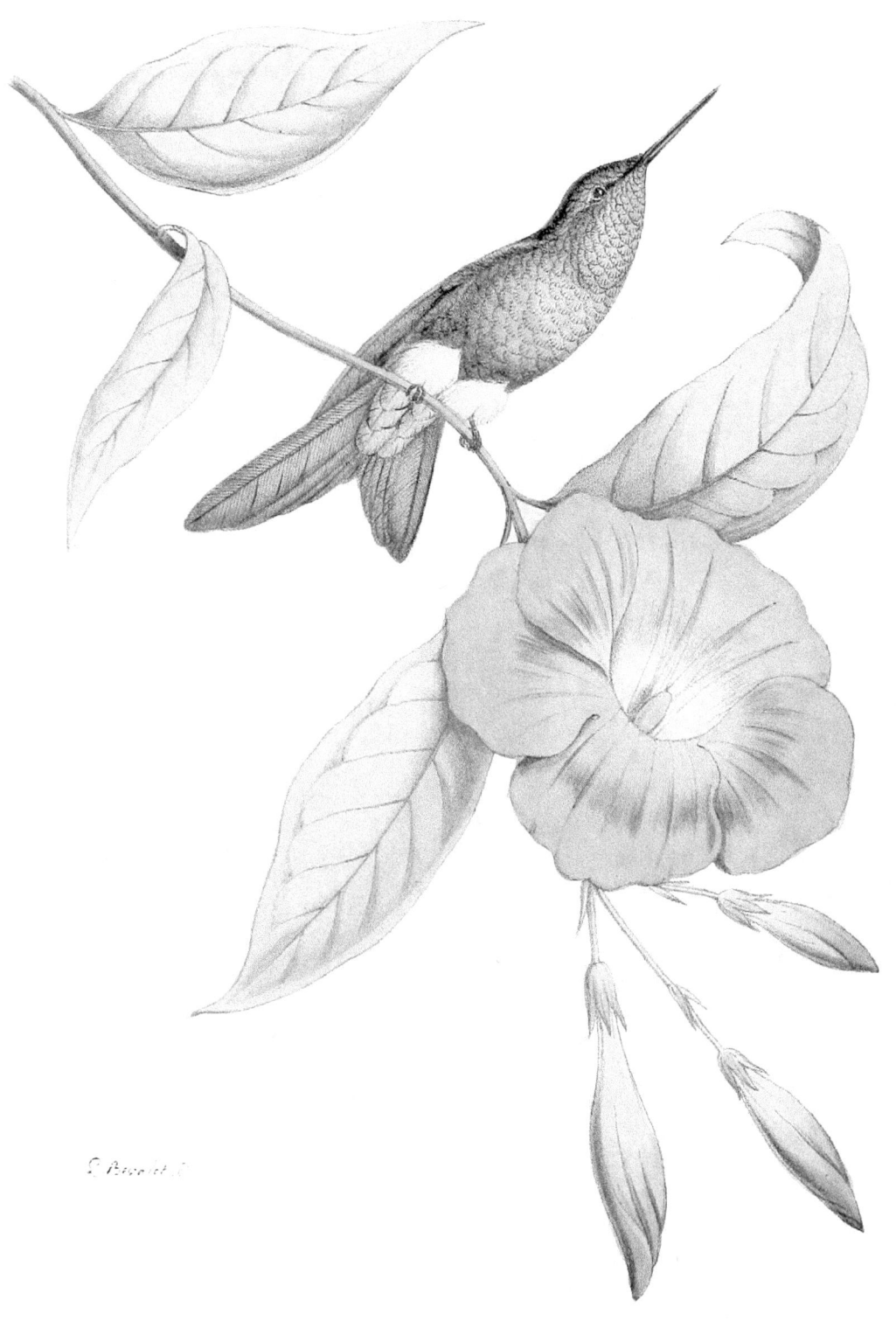

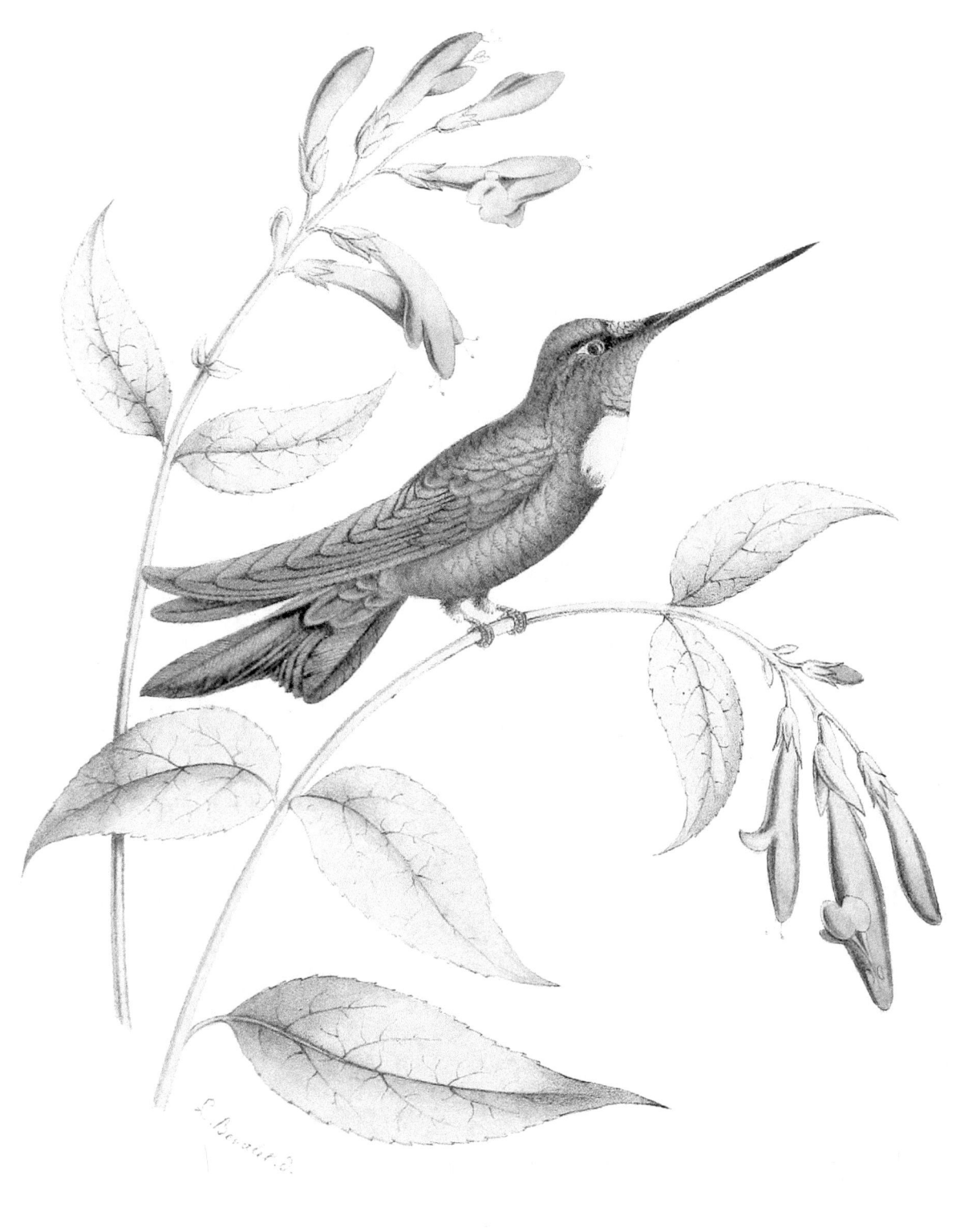

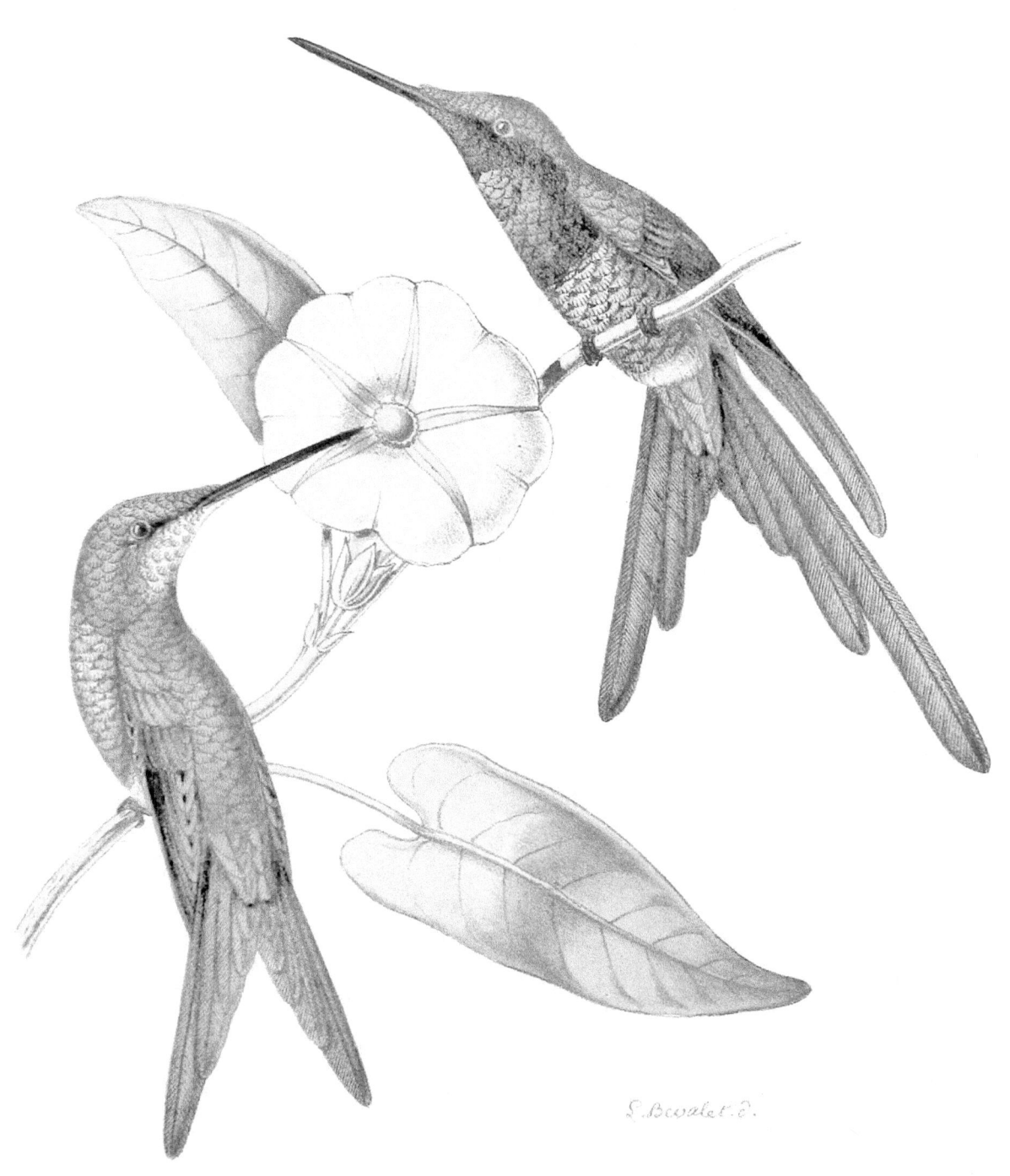

Bevalet's Hummingbirds and Flowers

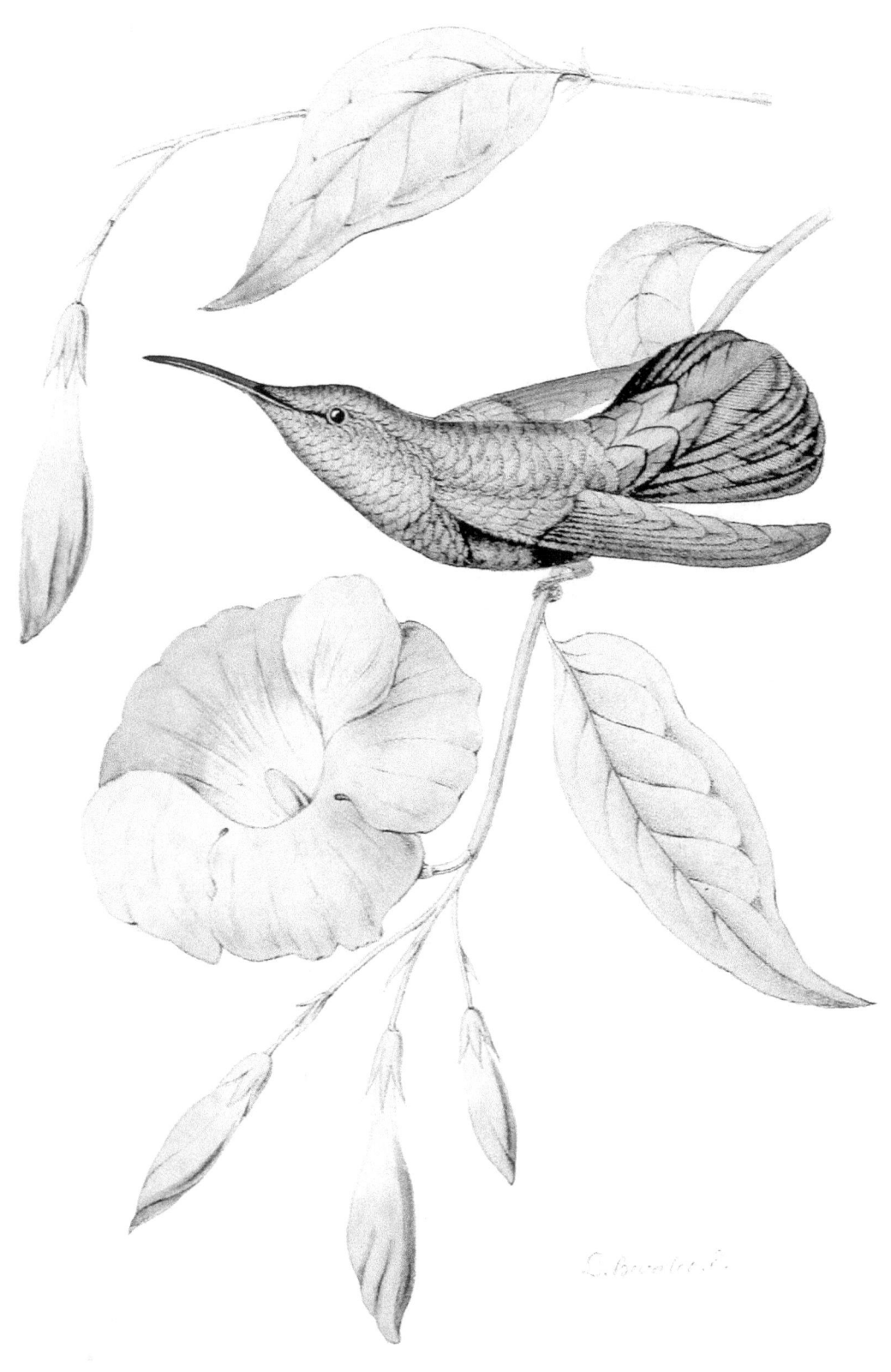

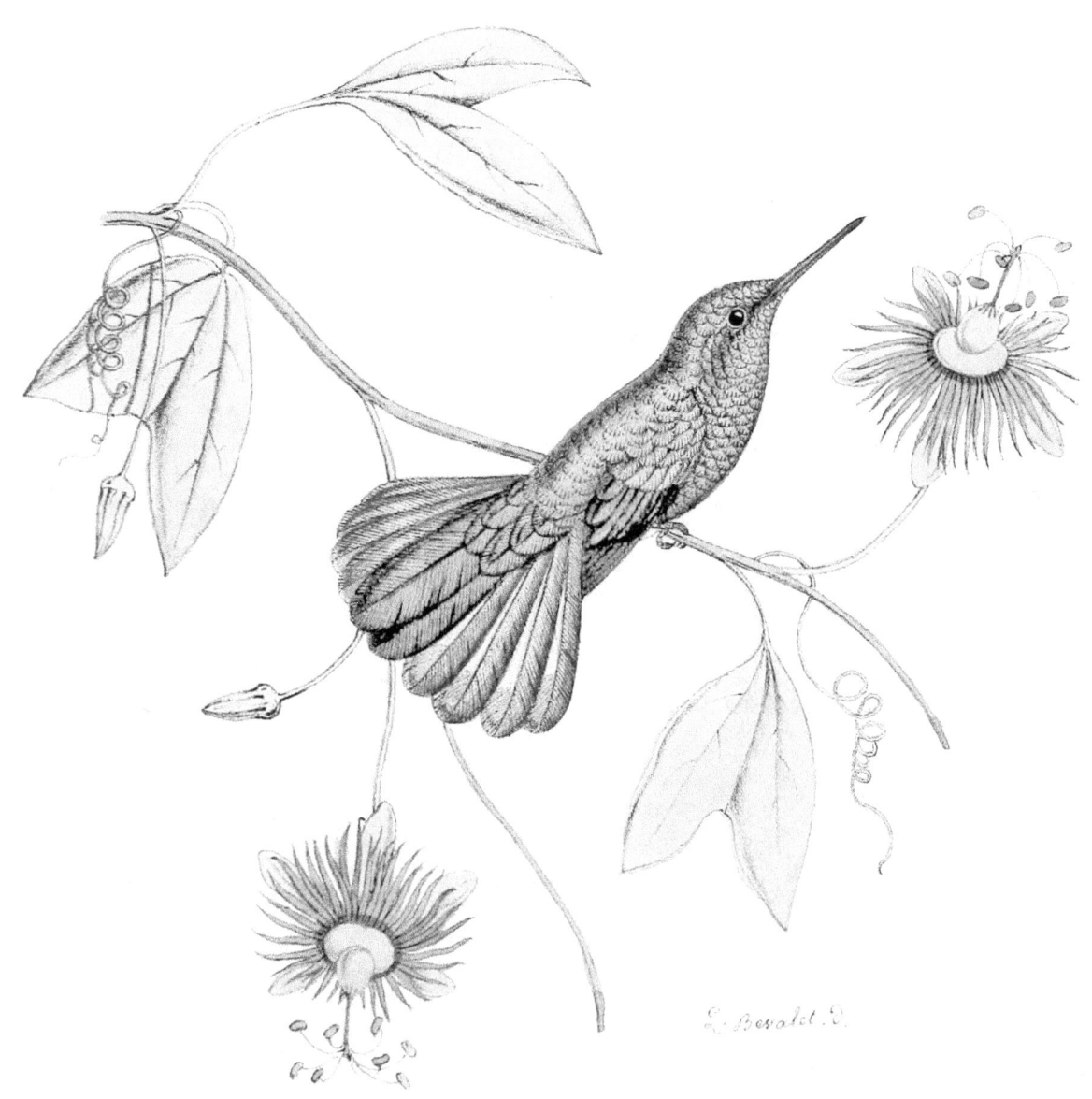

Bevalet's Hummingbirds and Flowers

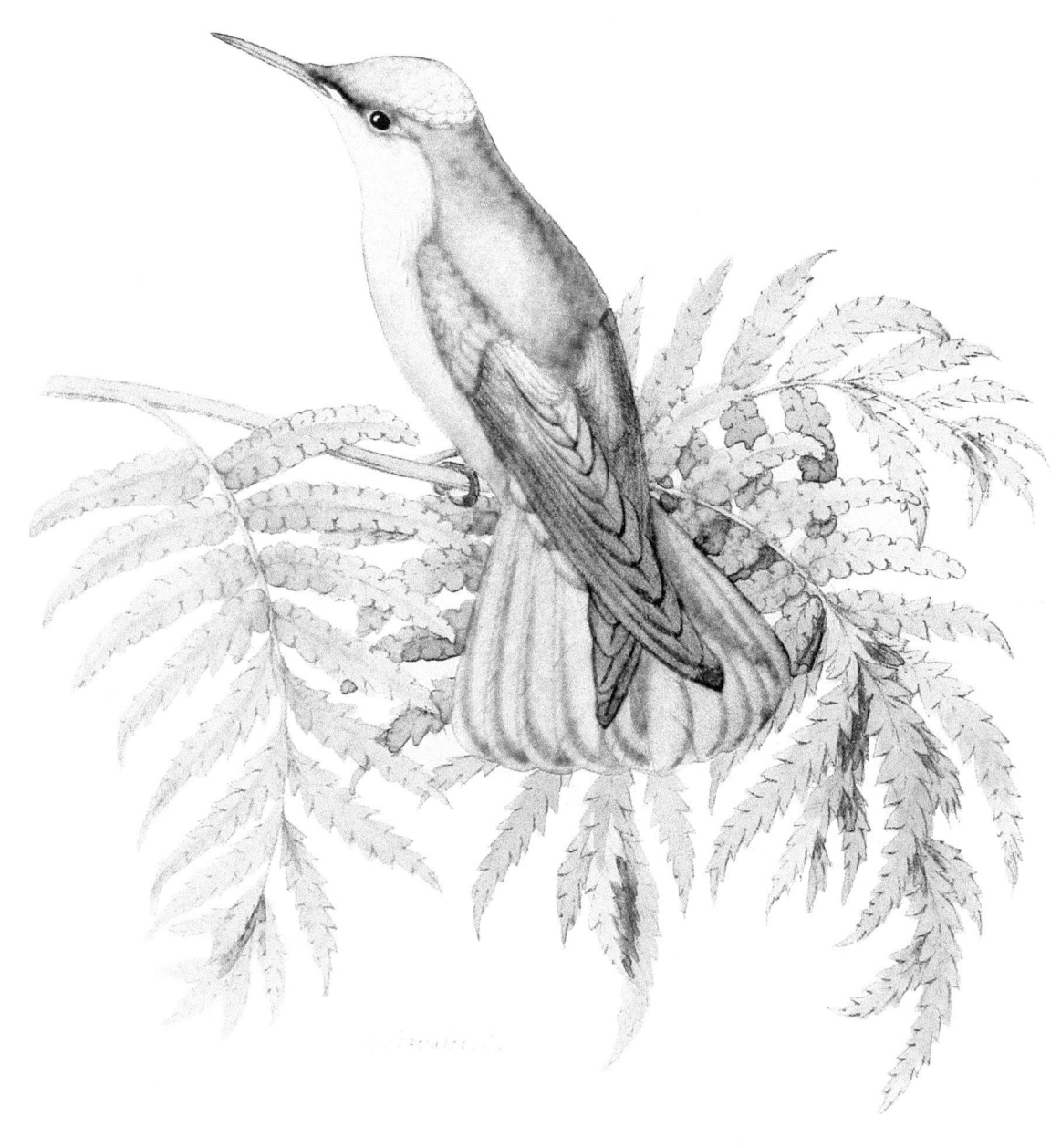

Bevalet's Hummingbirds and Flowers

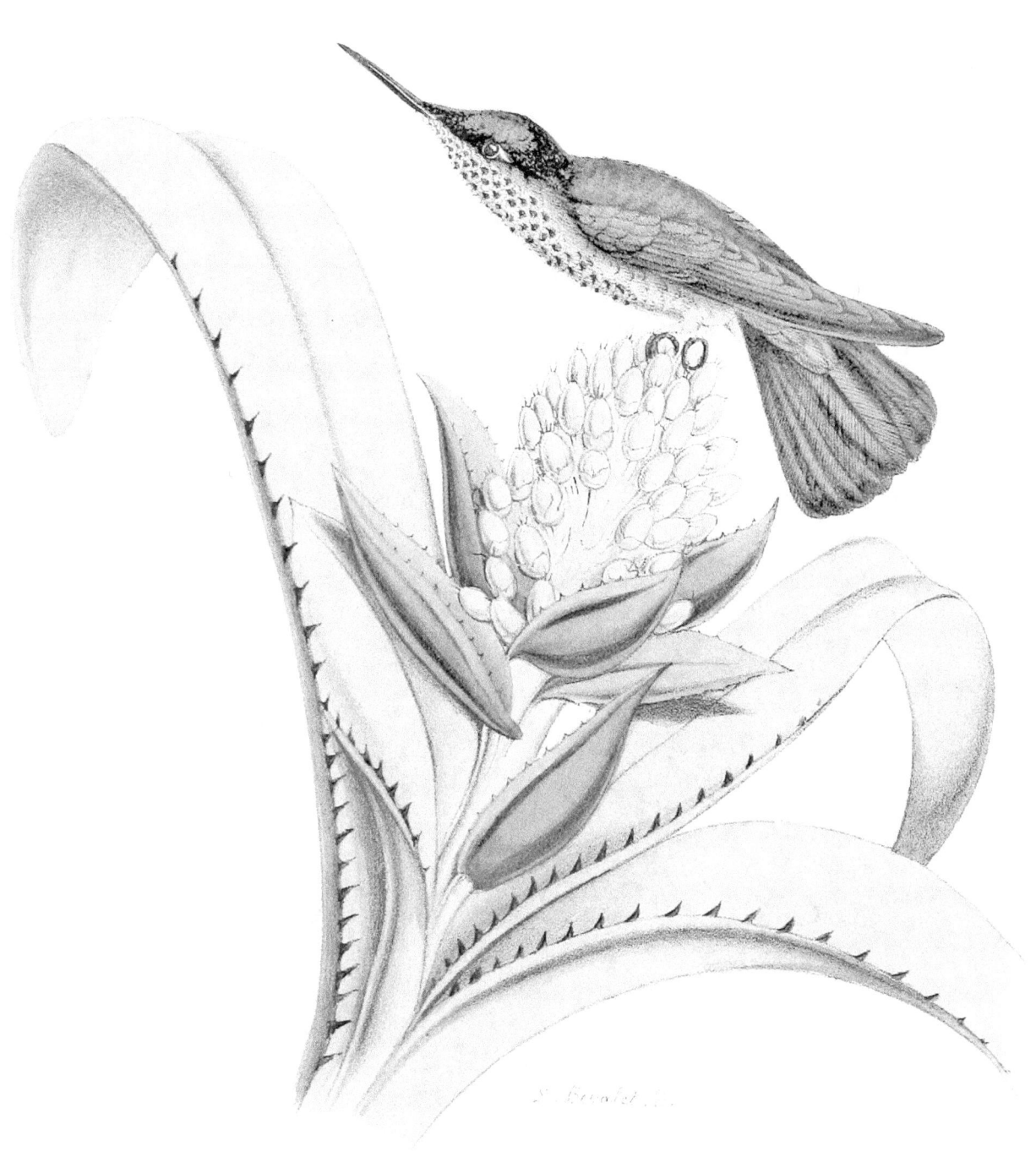

Bevalet's Hummingbirds and Flowers

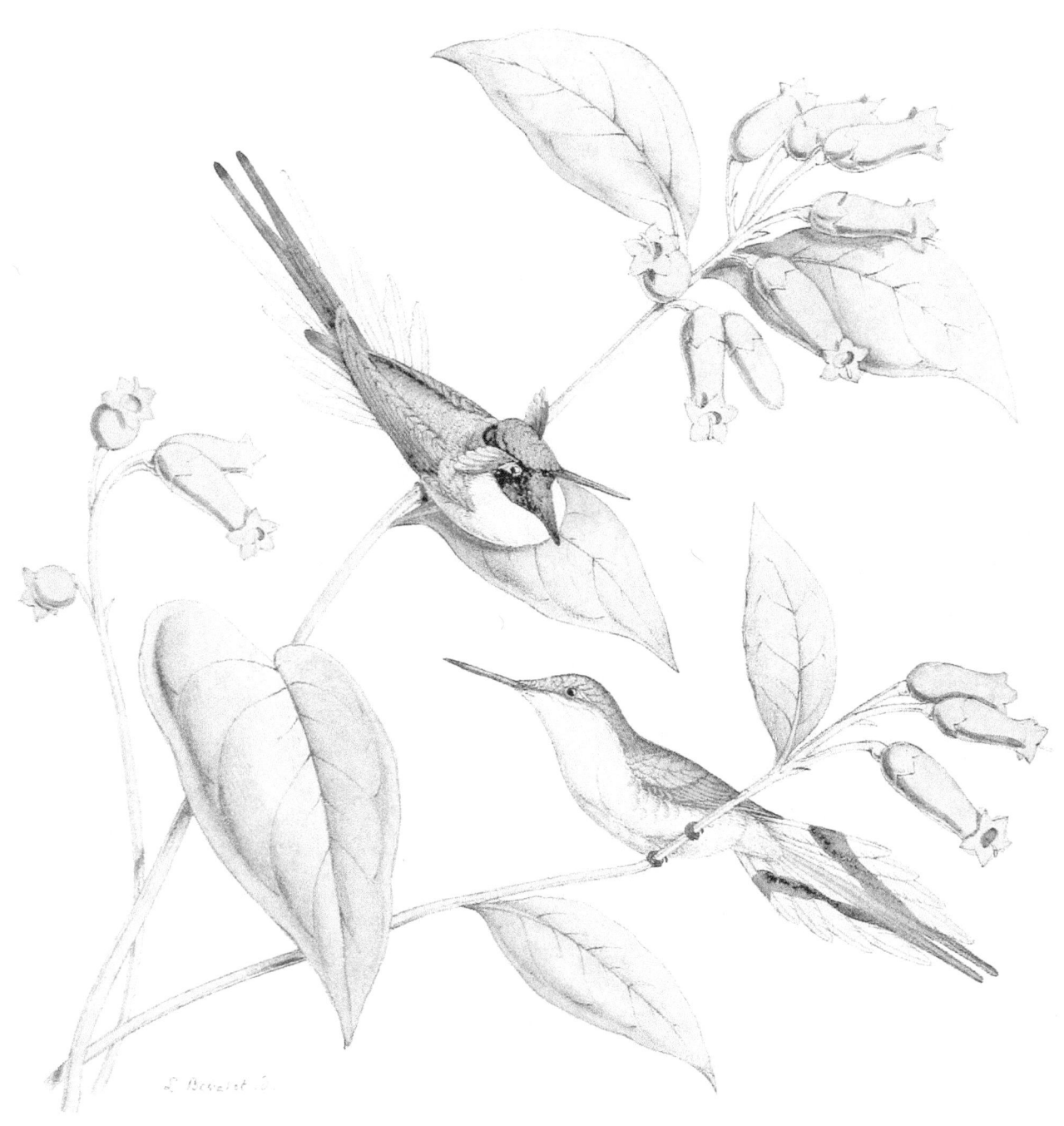

Bevalet's Hummingbirds and Flowers

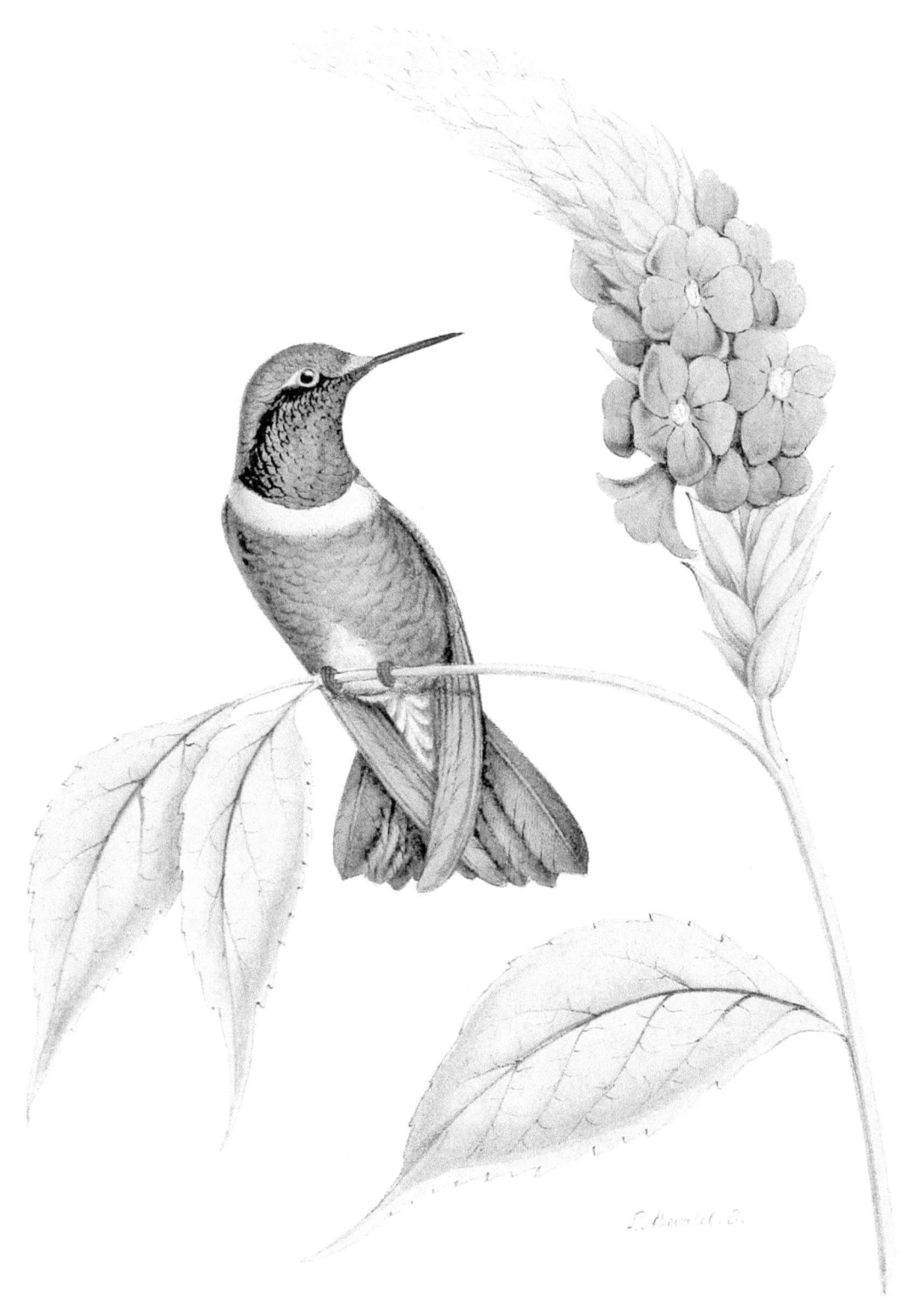

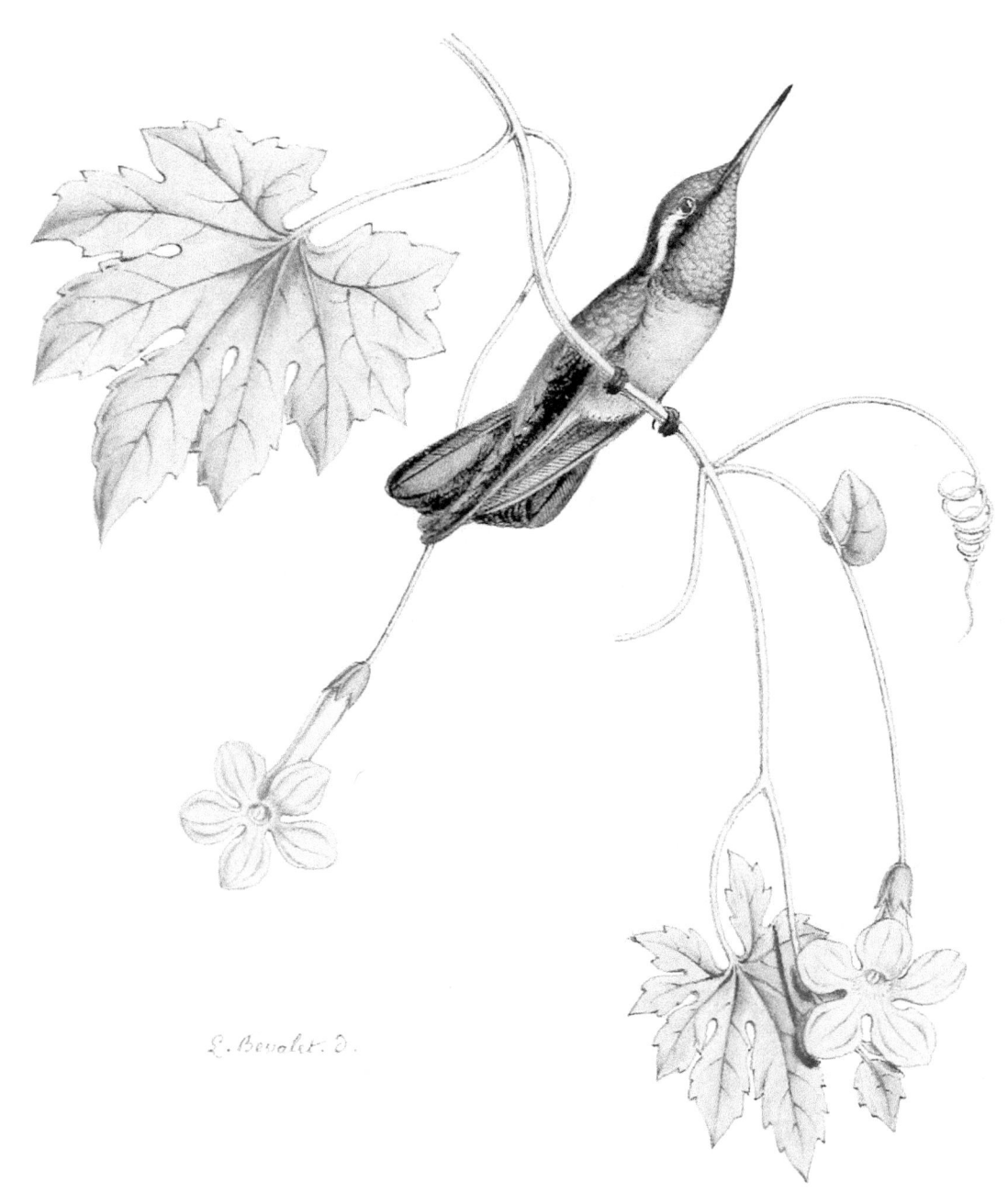

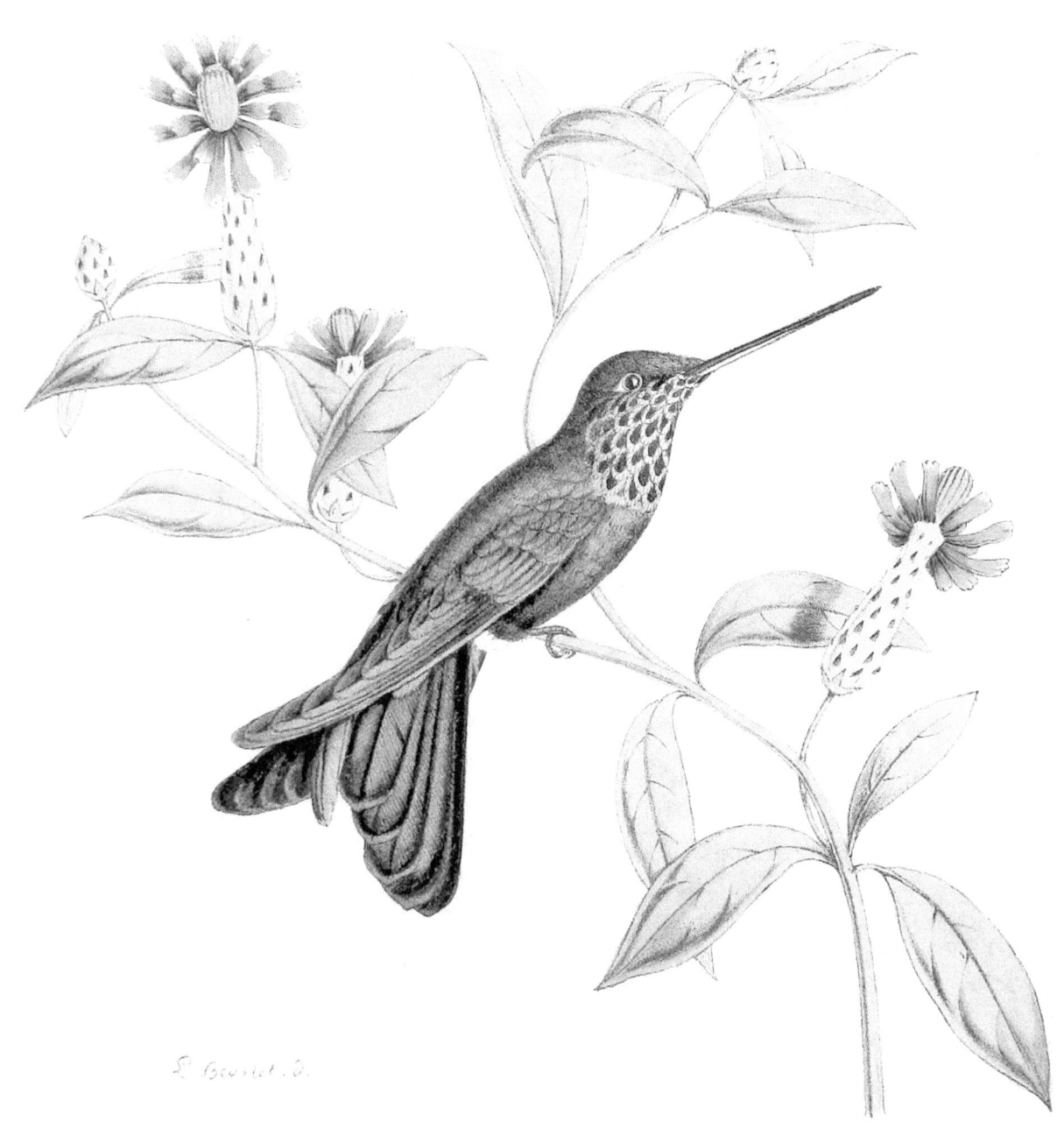

Bevalet's Hummingbirds and Flowers

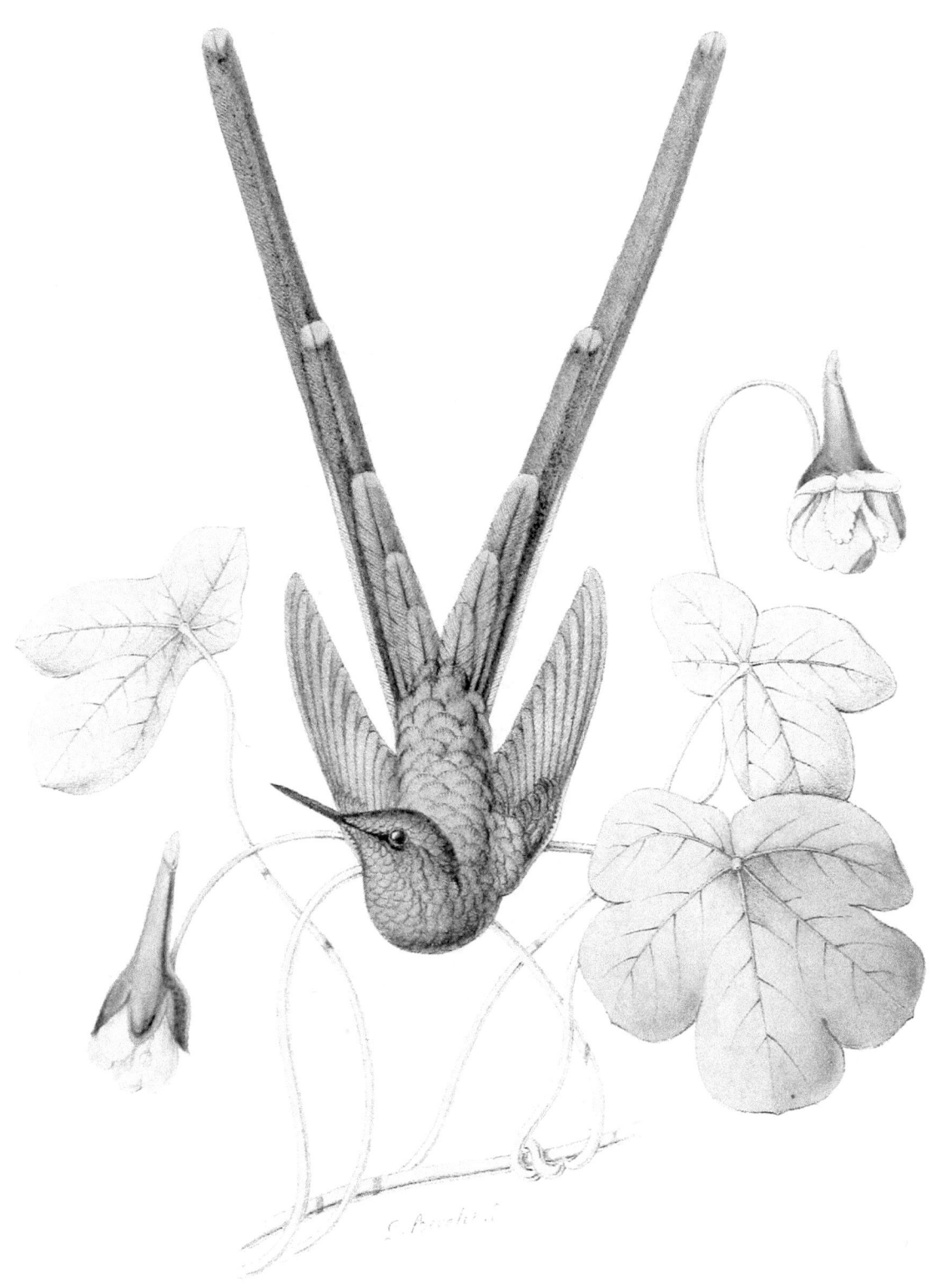

Bevalet's Hummingbirds and Flowers

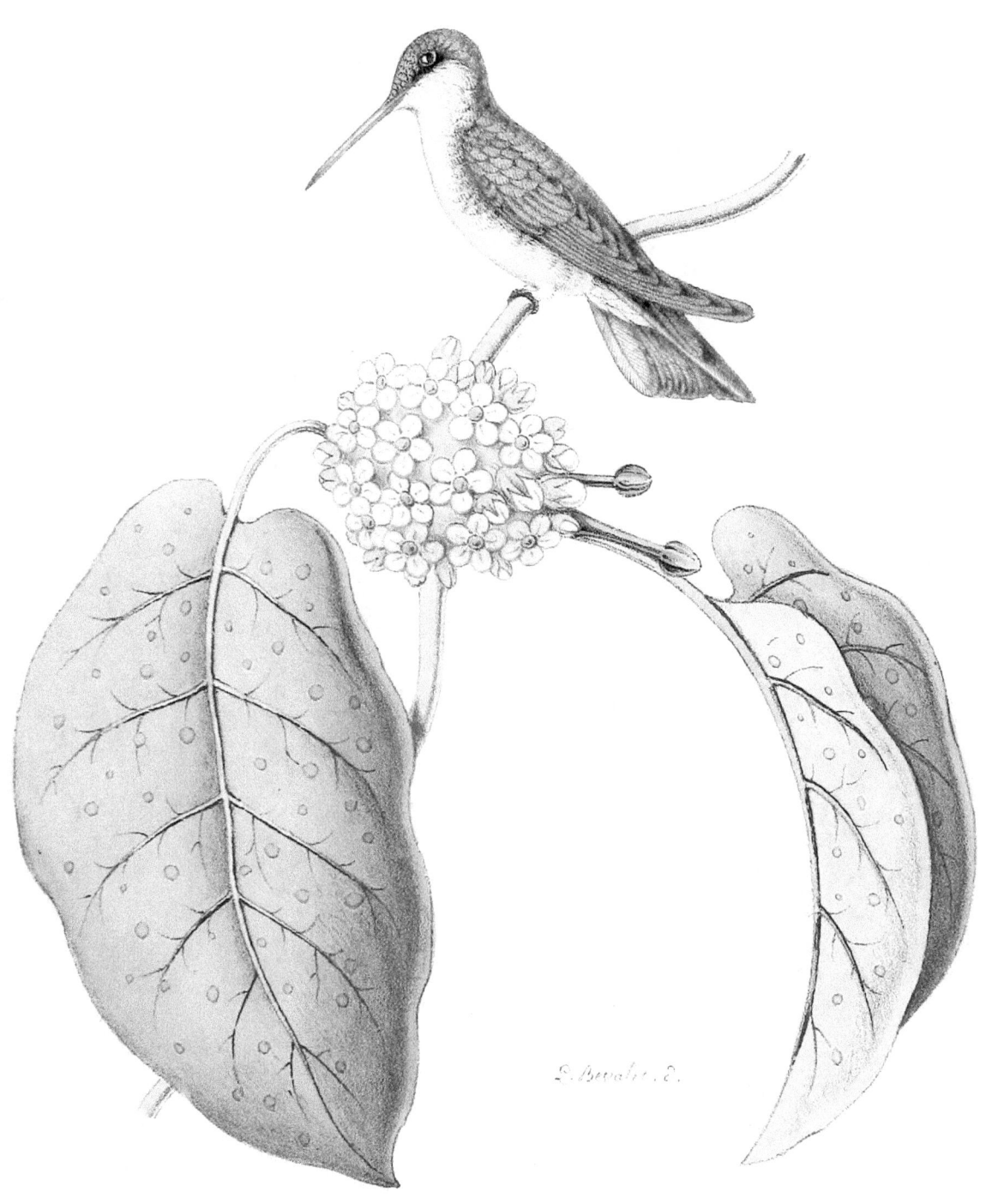

Bevalet's Hummingbirds and Flowers

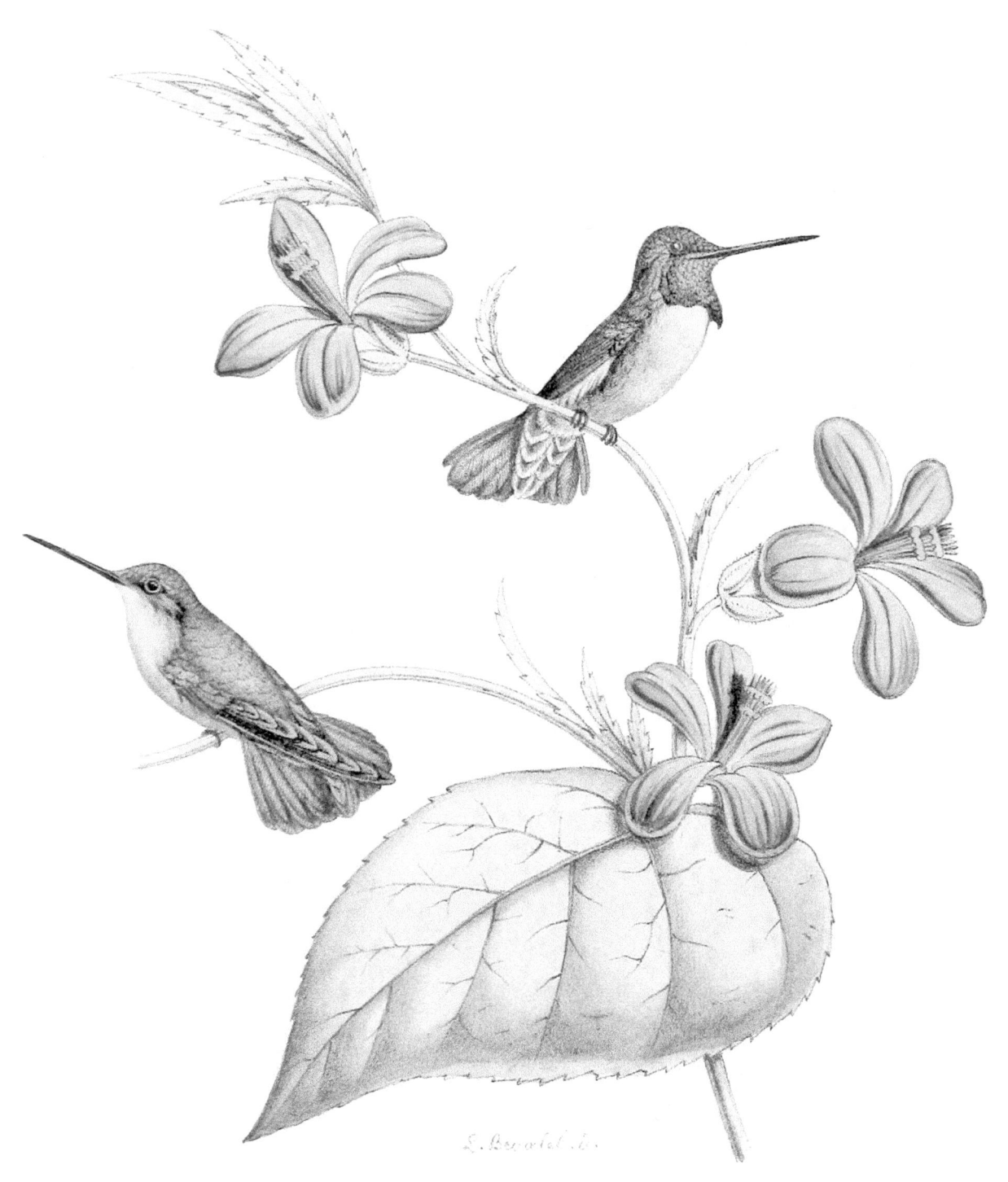

Bevalet's Hummingbirds and Flowers

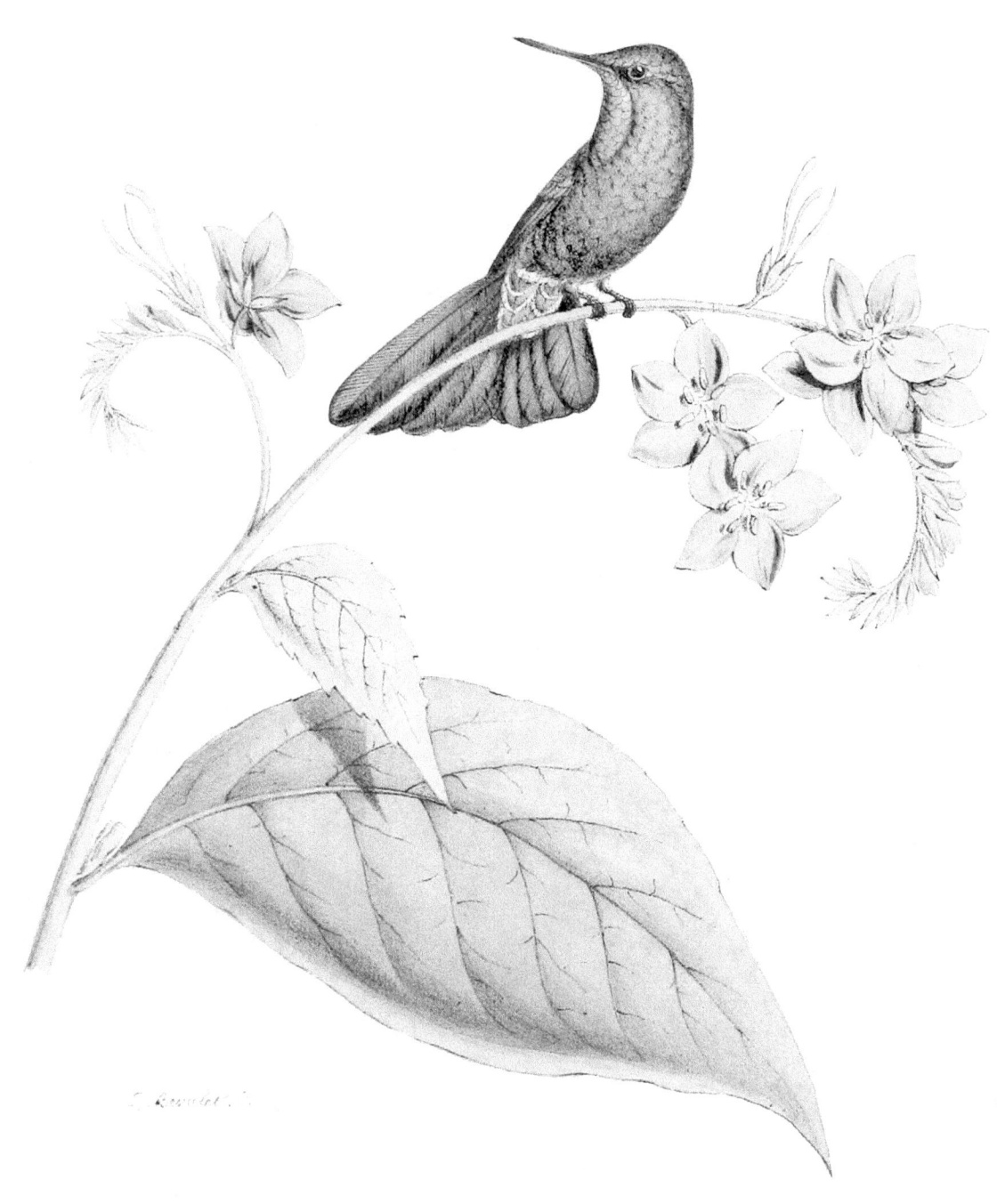

Bevalet's Hummingbirds and Flowers © Ligia Ortega - ColoringPress.com

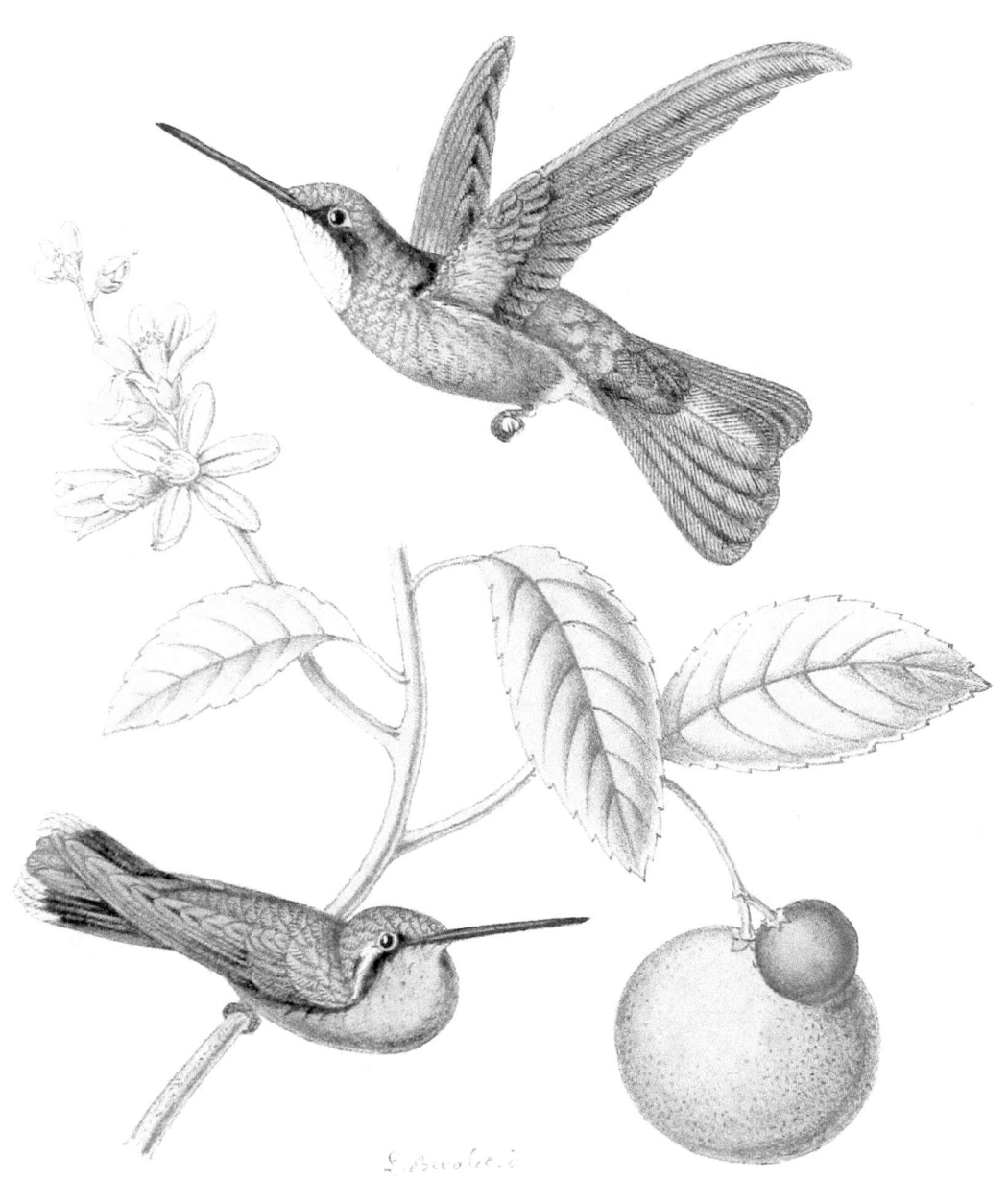

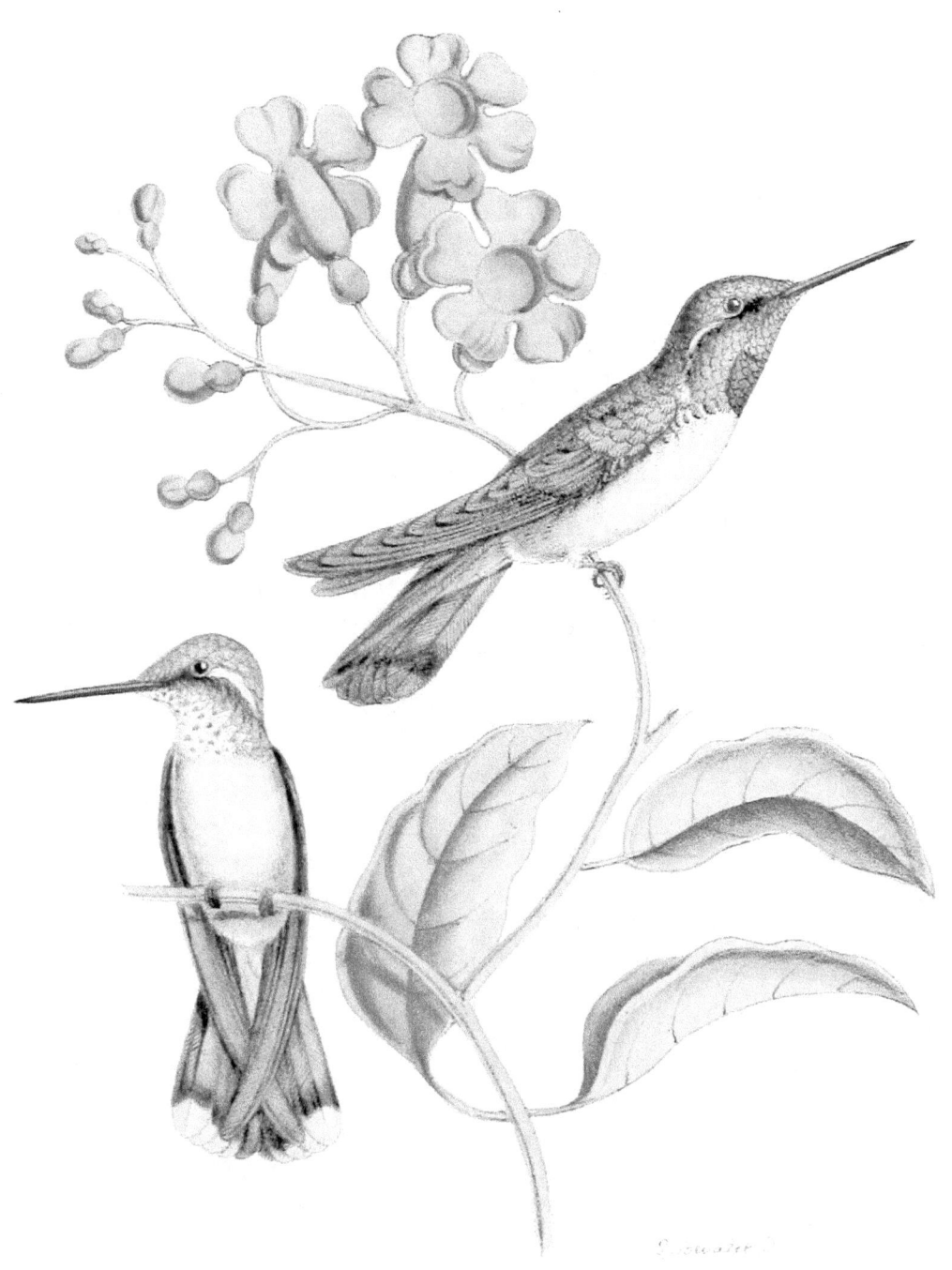

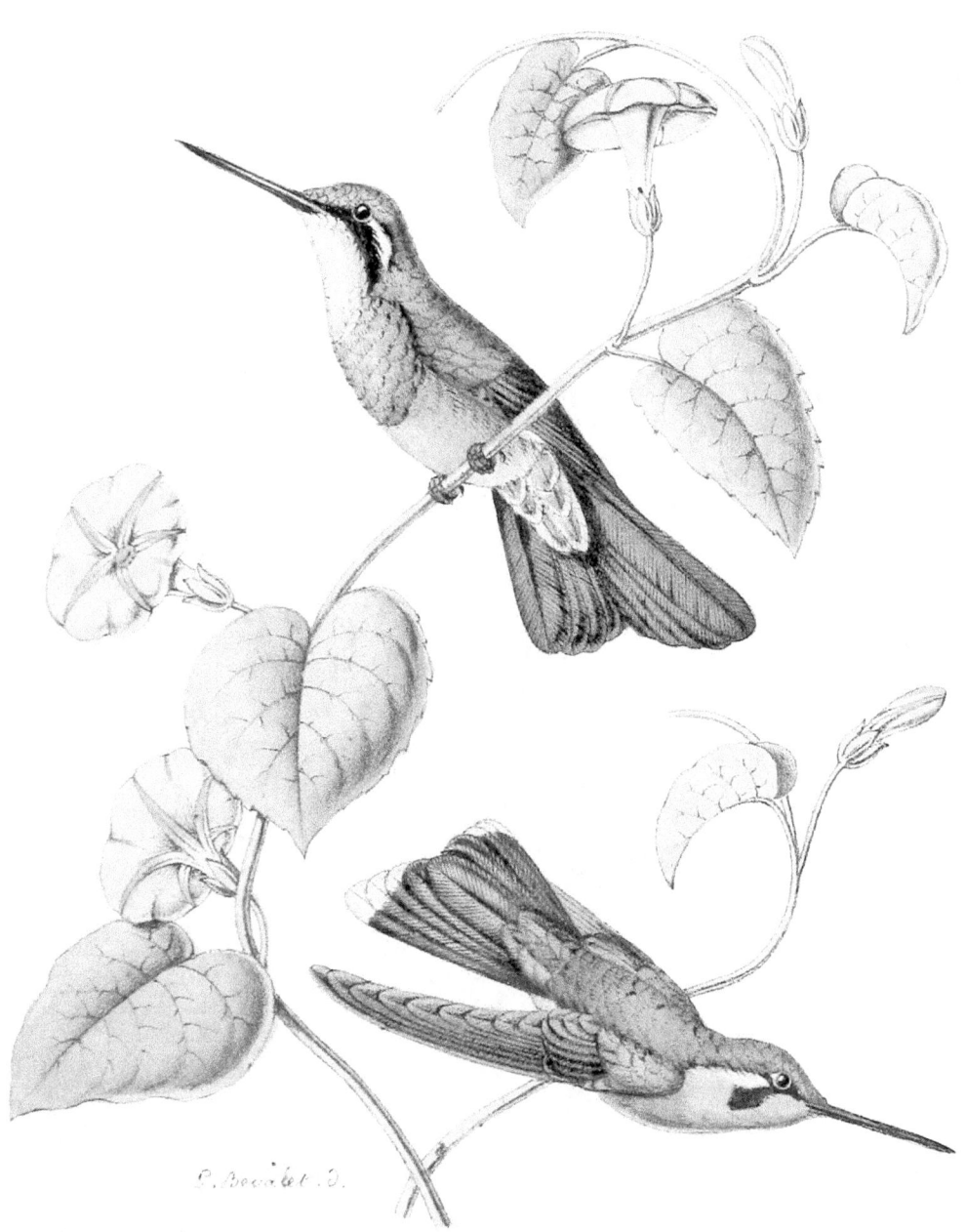

Bevalet's Hummingbirds and Flowers

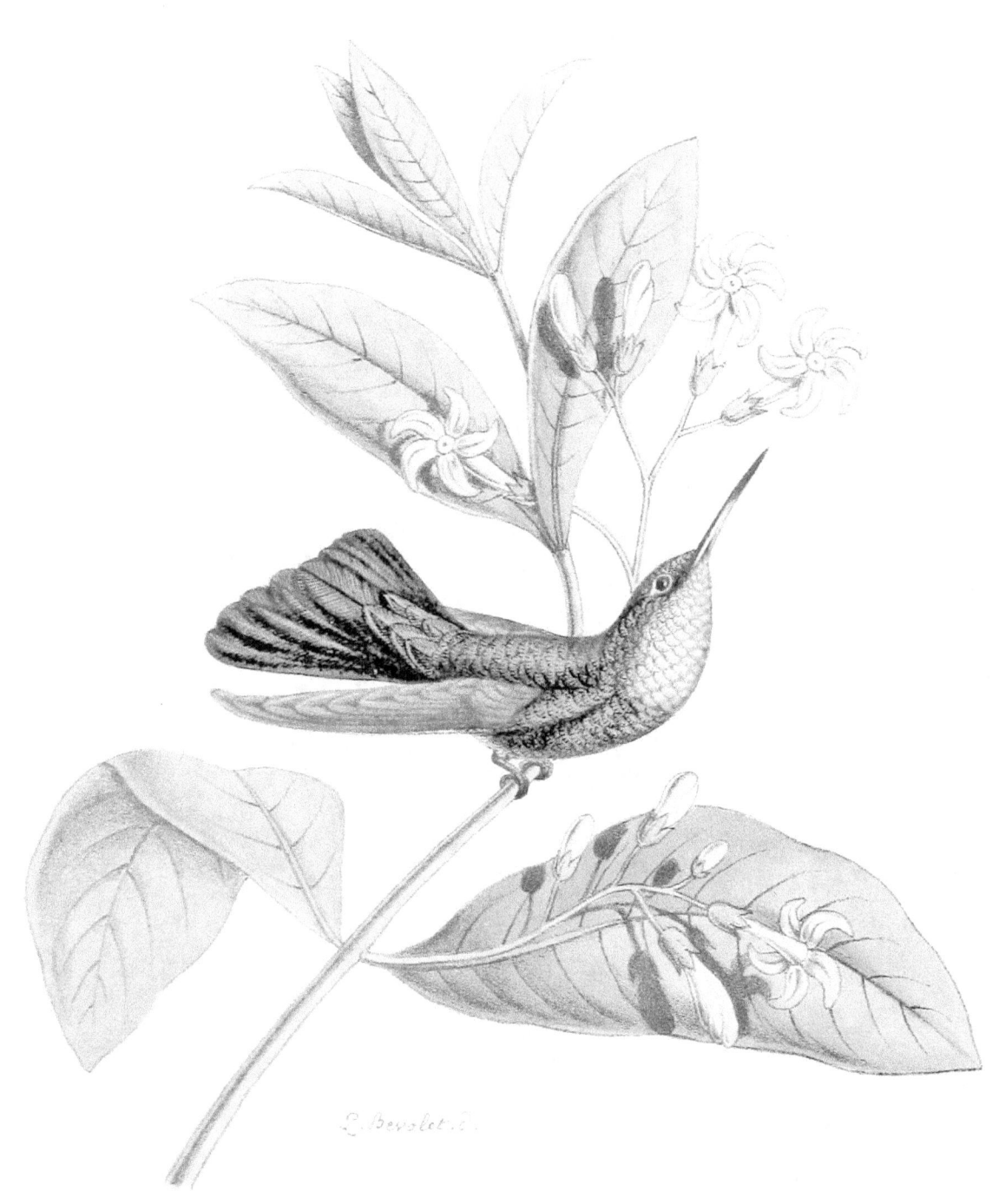

Bevalet's Hummingbirds and Flowers

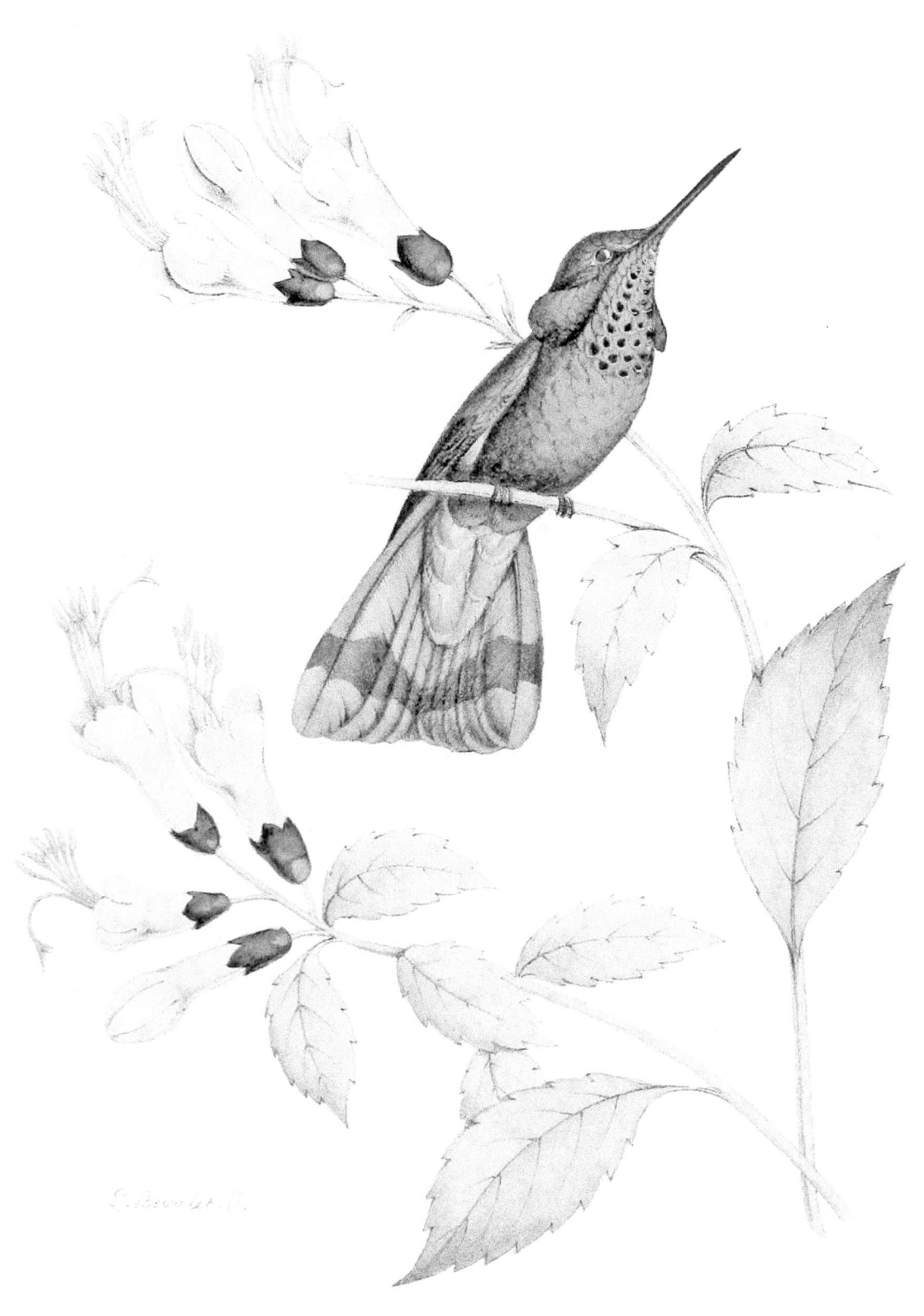

Bevalet's Hummingbirds and Flowers

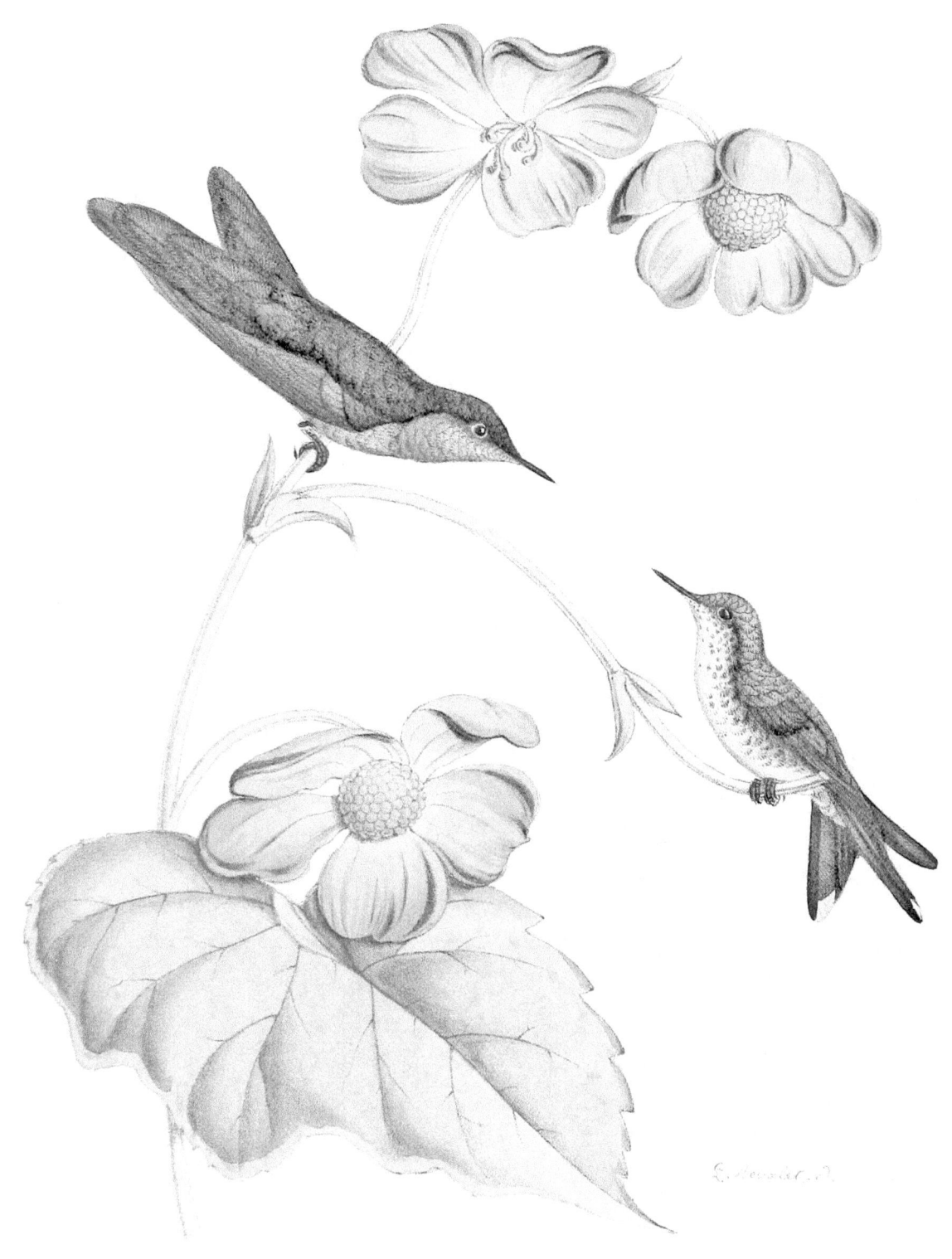

Bevalet's Hummingbirds and Flowers

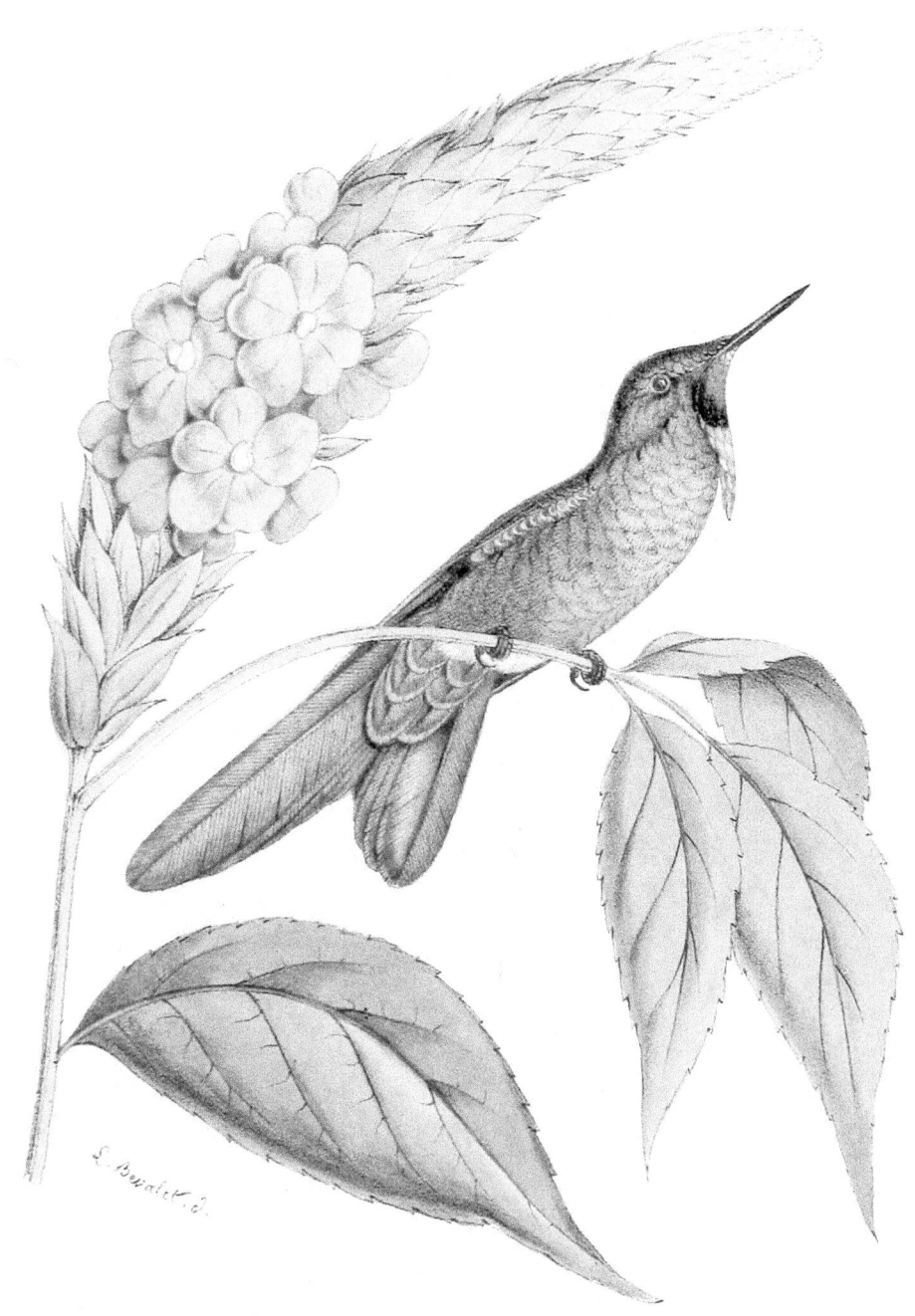

Bevalet's Hummingbirds and Flowers

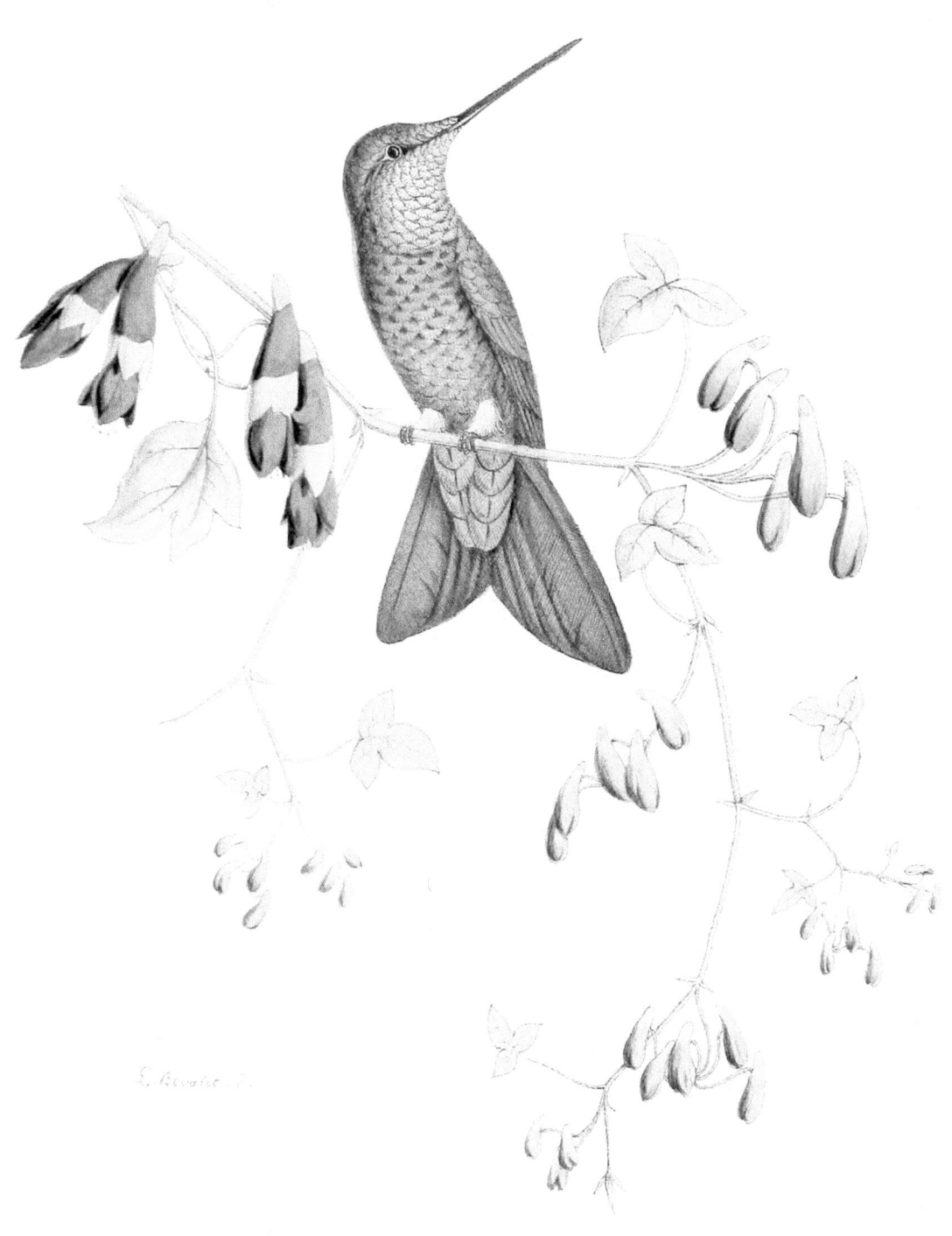

Bevalet's Hummingbirds and Flowers © Ligia Ortega - ColoringPress.com

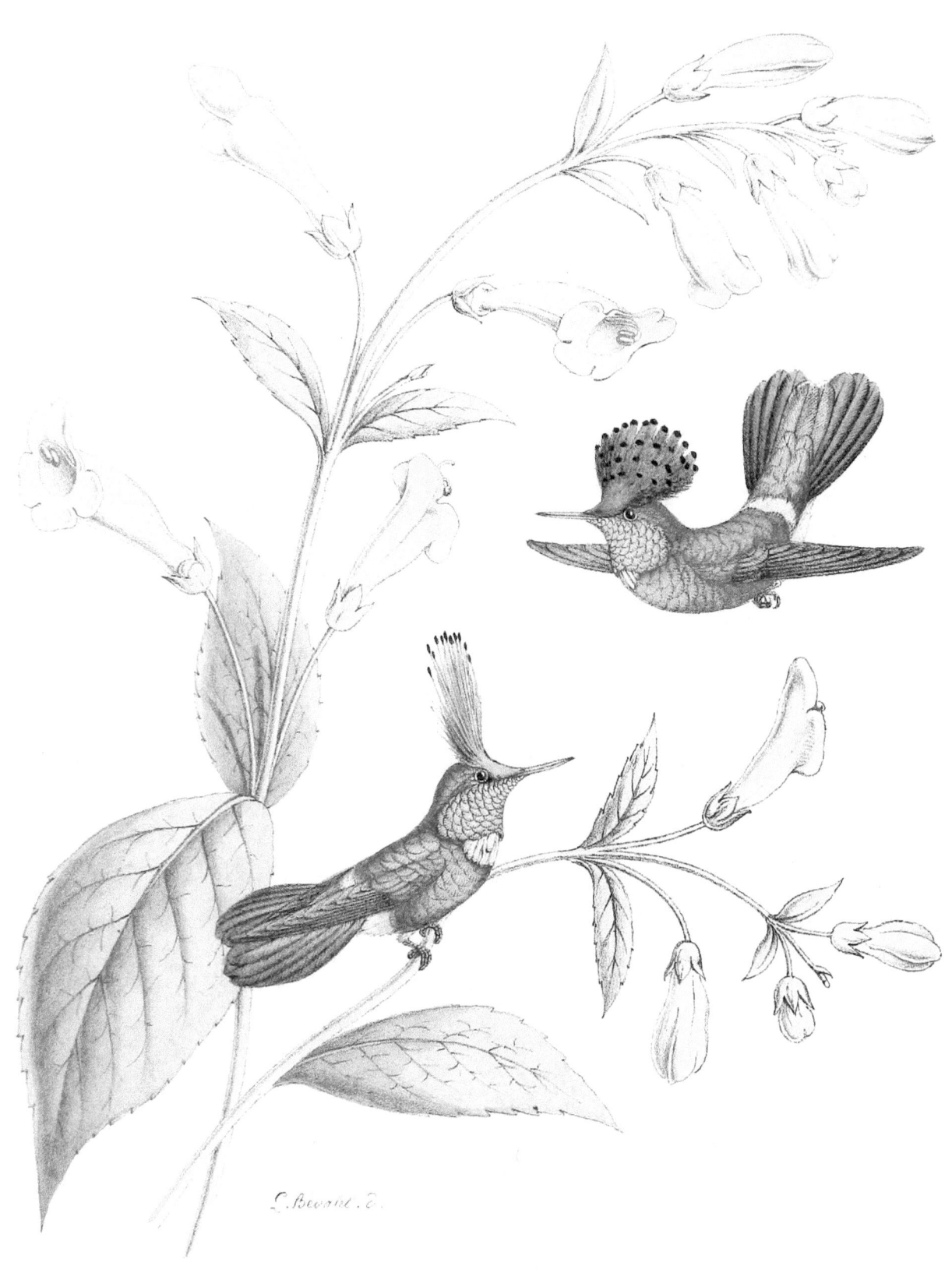

BONUS PAGES

In addition to the *Vintage Grayscale Adult Coloring Book* series, I have been working on other coloring books for adults. The following coloring pages are from books I have published under Coloring Press.

The first images are samples from Volumes 1-3 of my *Coloring Gifts*™ Book Series, *Coloring Gifts*™: *Gifts of Thanks*; *Coloring Gifts*™: *Gifts of Encouragement*; and *Coloring Gifts*™: *Gifts of Friendship*. These themed adult coloring books each have 24 original hand drawn pages printed in two different sizes (full size and craft size, approx. 5x7") plus nine coordinating bookmarks. Pages can be colored and given as is, or framed, turned into cards, or made into bookmarks using the included instructions. These pages can also be used to aid prayer or meditation with the enclosed instructions to reap the full health benefits of coloring and gratitude, encouragement, and friendship. I am already working on the next volume of *Coloring Gifts*™. Visit ColoringPress.com for more information on *Coloring Gifts*™.

The fourth and fifth images are from my *Vintage Grayscale Adult Coloring Book* Series, Volume 1 *Arthur Rackham's Fairies and Nymphs* and Volume 2, *Warwick Goble's Fairy Tales*. I am already working on Volume 4 of this series. Visit ColoringPress.com for more information on grayscale coloring.

The remaining images are from my *Simple Kaleidoscopes* coloring books. I took on the challenge of making kaleidoscope images by hand rather than having software generated ones. It was fun watching them come to life from my own hand-drawn black and white coloring image. These kaleidoscopes are published as full size 8.5x11" books and also as travel size 6x8" book. Black background versions are in the works too. I published these books in response to colorists asking for a less intricate kaleidoscope where they could show off their shading or just have larger spaces to color. Their bold lines and larger spaces also work well for people with low vision or issues with hand control. The travel size books are perfect for taking with you to the mechanic, the dentist, the doctor's office, or any place where you may have to wait. They make the time fly by quickly and the wait a lot more pleasant, and their small size means you can usually finish coloring a page in one sitting. This series is being well received by colorists and I will be publishing additional Simple books in different themes including flowers, mandalas, and others.

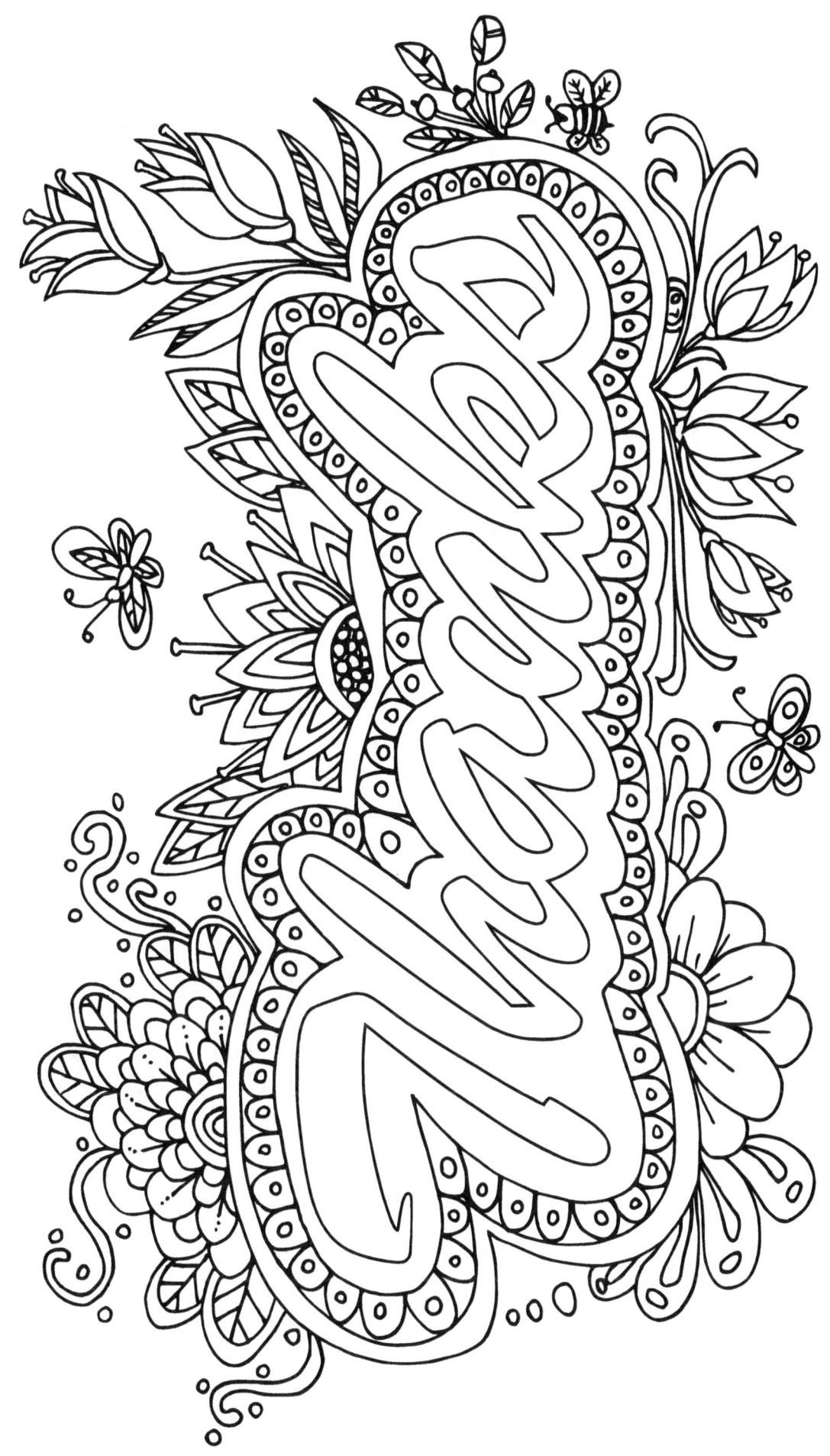

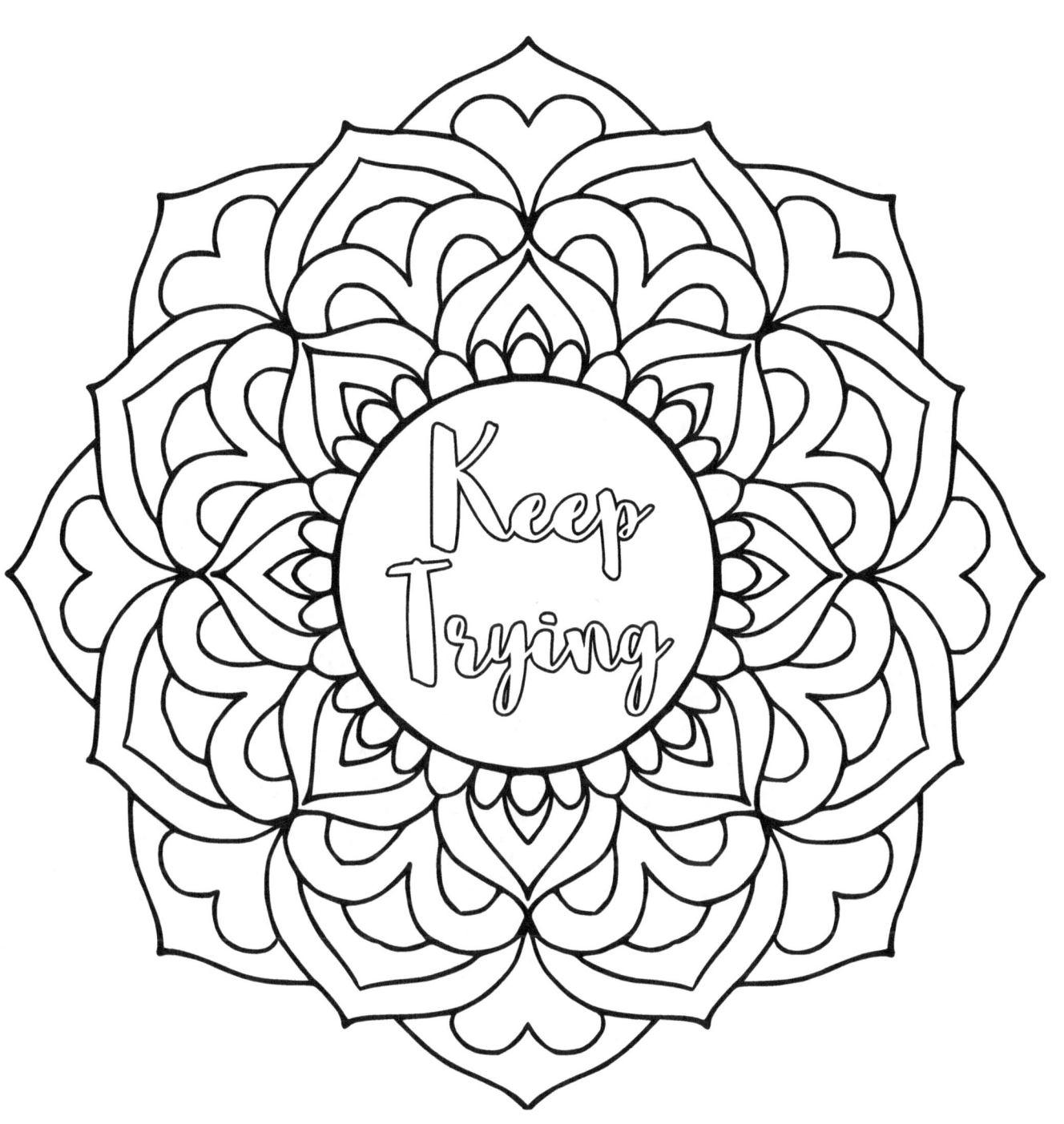

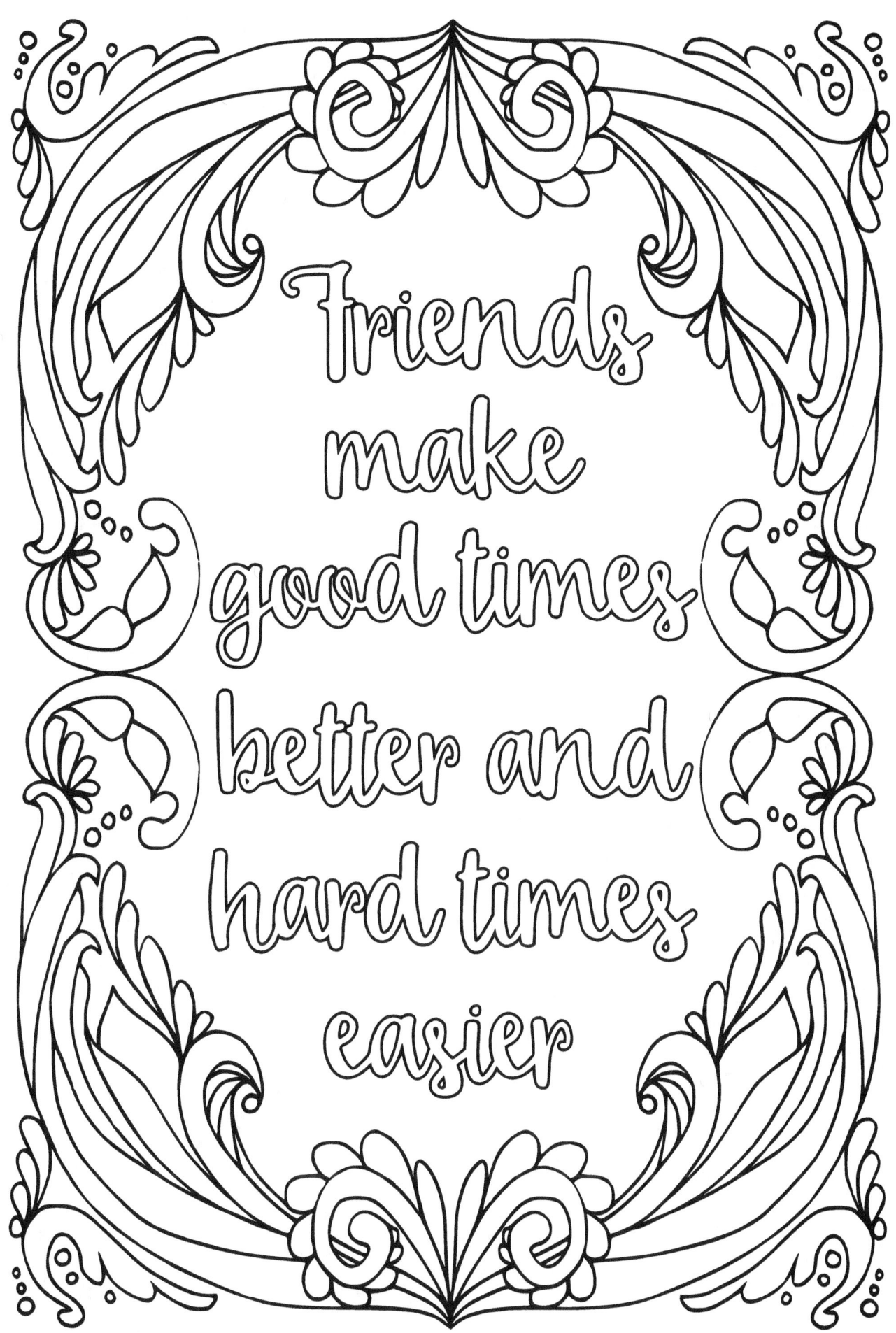

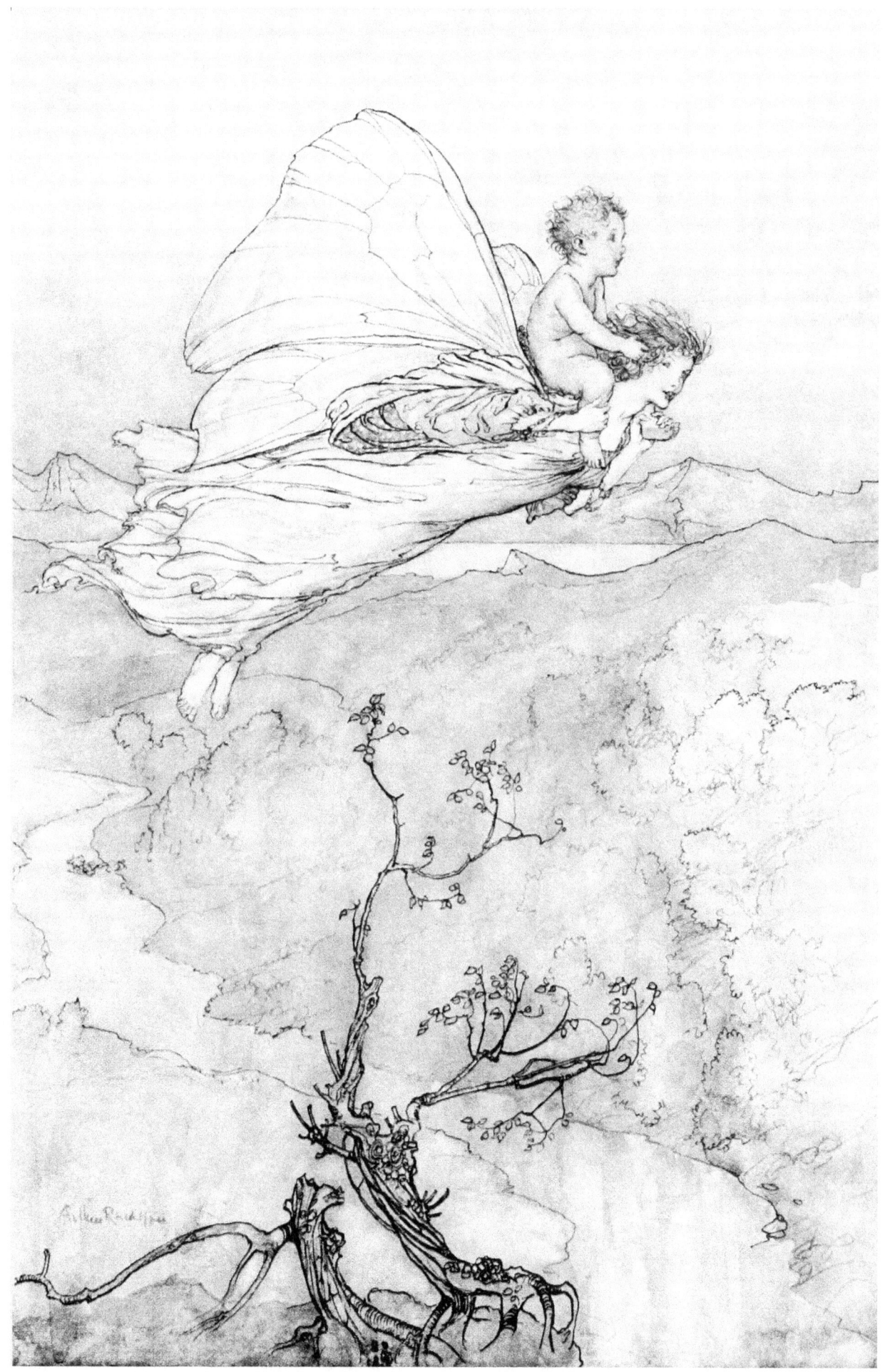

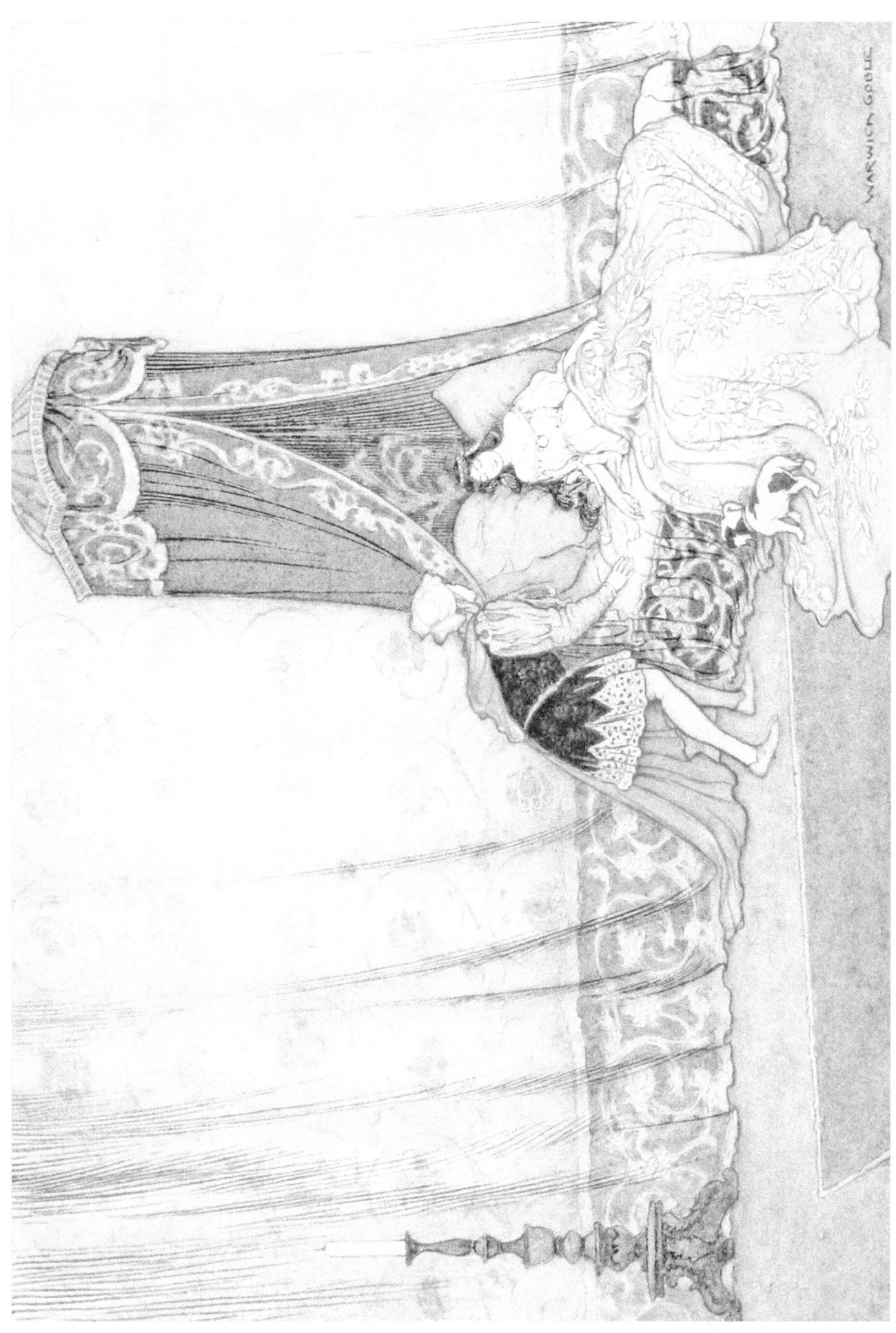

TEST & RECORD YOUR FAVORITE PALETTES & COLOR COMBINATIONS!

The Colorist Palette Reference Book works as a place to:
- keep track of your favorite color combinations
- test drive new media
- help you remember what supplies you were using if you have to pack them up /put them away before you finish coloring a page
- test and practice new techniques before you work on a coloring page
- experiment with new palettes to see if the colors play together nicely
- keep track of colors you used on a coloring page

The book has 48 full size pages in 12 different designs.
There is a small simple picture on the top half of each page and the bottom has space for swatches and lines for recording color and/or media that you used, or to take notes or keep track of blending.
The image does not have to be colored fully, it's there to see how the colors go together or for you to try new techniques. There is blank space too for notes about which coloring page you used the particular palette, media, or technique on.
This book came out of my own needs as a colorist, so I hope it will be useful! This book does not have colored pages, they are blank so you can record your own favorite palettes, combinations, or notes.

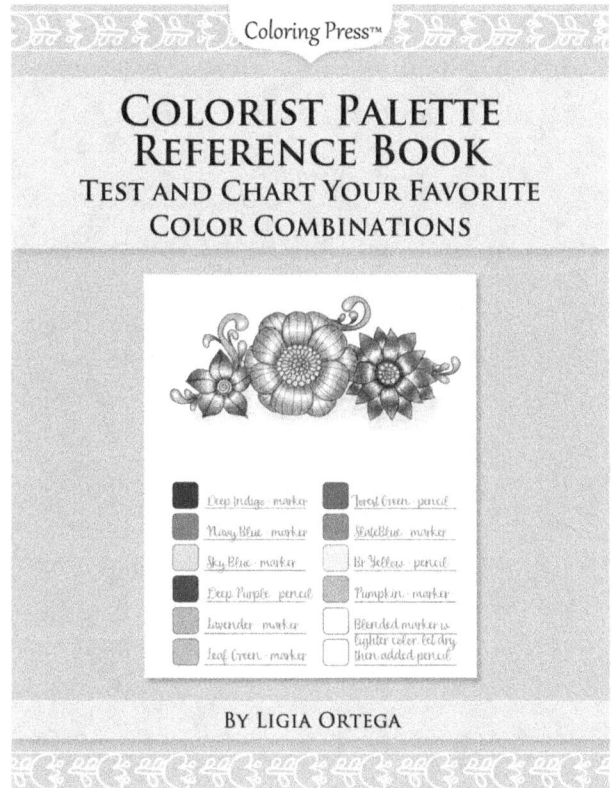

The 12 designs in the book

I hope you enjoyed Bevalet's Flowers and Hummingbirds!

Please take a moment to leave a review on the book's Amazon page.

To find other volumes of Vintage Grayscale Adult Coloring Books, for grayscale coloring tips, to share your colored pages on Facebook, and to find my other adult coloring books, please visit:

ColoringPress.com